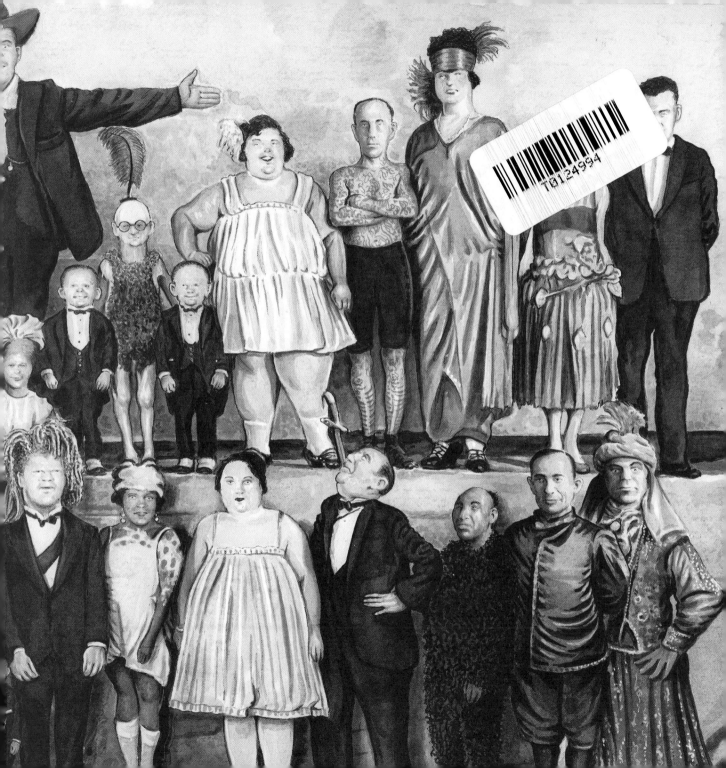

DREW FRIEDMAN'S
SIDESHOW
FREAKS

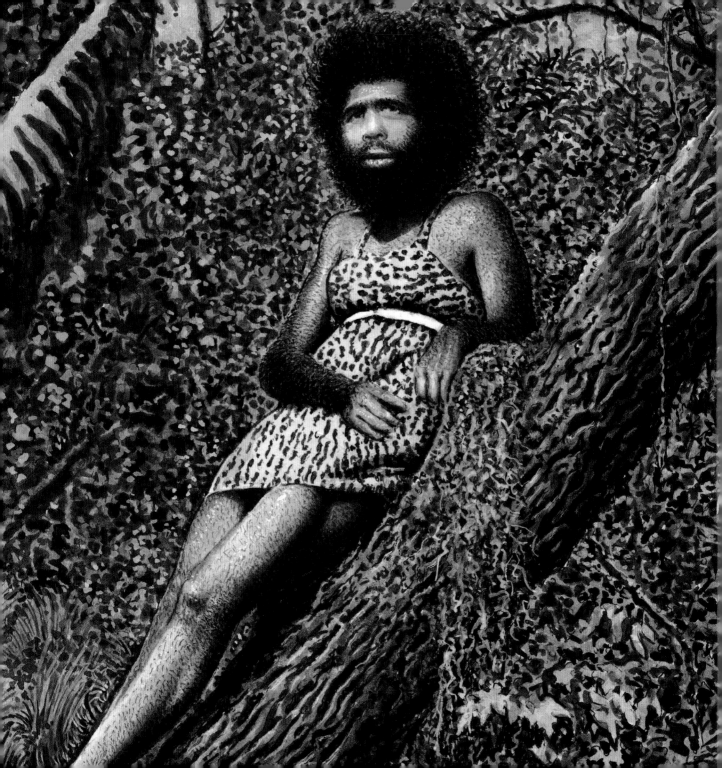

DREW FRIEDMAN'S SIDESHOW FREAKS

TEXT BY DREW FRIEDMAN & K. BIDUS

FOREWORD BY

PENN JILLETTE

Blast Books
NEW YORK

Dedicated to Tod Browning

page 2: Percilla the Monkey Girl, detail, page 67

Blast Books gratefully acknowledges the generous help of
Donald Kennison, Ken Siman, and James Taylor.

Library of Congress Cataloging-in-Publication Data
Friedman, Drew.
 Drew Friedman's sideshow freaks / text by Drew Friedman & K. Bidus ;
foreword by Penn Jillette.
 p. cm.
 ISBN 978-0-922233-36-6 (alk. paper)
1. Friedman, Drew—Themes, motives. 2. Abnormalities, Human, in art.
3. People with disabilities in art. 4. Freak shows. I. Bidus, K. II. Title.
III. Title: Sideshow freaks.
 NC1429.F6694A4 2010
 741.5'6973—dc22 2010011163

Published by Blast Books, Inc.
P.O. Box 51, Cooper Station
New York, NY 10276-0051
www.blastbooks.com

Edited and designed by Laura Lindgren

Printed in China

10 9 8 7 6 5 4 3 2 1

"We are in the same tent as the clowns
and the freaks—that's show business."
Edward R. Murrow

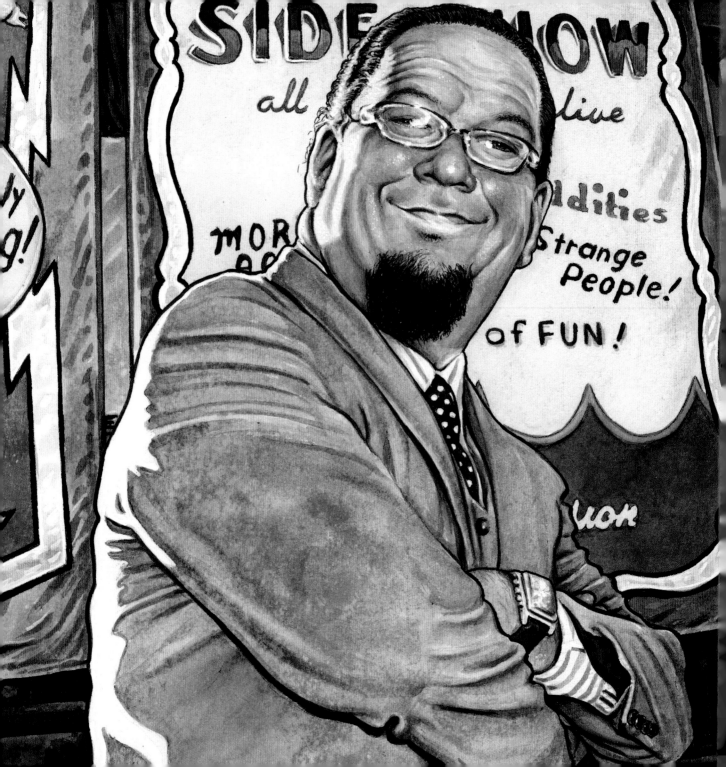

FOREWORD

PENN JILLETTE

There was a strip club in Saint Paul, Minnesota, that because of weird-ass zoning laws had to have the naked dancing women in one building of the strip mall and the patrons behind a glass wall in a technically different building. I was brought to "The Best Ass Behind Glass" many years ago by my buddy and co-worker "Snot" (1951–2008, born Joseph Gerard Kudla in Minneapolis, Minnesota; Mr. Kudla worked under the name "Snot" in Renaissance Festivals as a Shakespearean actor/comedian/stunt man with the act "Puke & Snot."). As Joe was driving me to this partitioned strip-mall titty bar, he said, "It's like a girl zoo."

I like strip clubs. I'm uncomfortable and excited to see people on display. Whenever a table dancer at a "gentlemen's club" would do the conversation part of her job with me and ask what I did for a living, I would answer, "I have the same job as you." Sometimes they would wonder how a 6' 7", 278-pound man secured enough lap dances to make ends meet without giving up too much in the V.I.P. lounge, but mostly they understood. There's lots of show business and it's all the same. Teller (1949–, born in Philadelphia,

Pennsylvania, real name unknown; works as "Teller" in "Penn & Teller" doing a comedy/magic act) once said that we did tricks and bits in our show so people would have an excuse to stare at us. People all just want to stare at other people.

I'm from a small, dead factory town, Greenfield, in western Massachusetts. There was no live showbiz in Greenfield. Once a year the carnival would come to town. In the early '70s there were still "10-in-1s," as the freak shows are called on the inside. I've done a few monologues about going to those freak shows, but I'm lying in those speeches about most of my freak show visits. I didn't really go into the tent much. I didn't really see many of the freak shows. I stood on the midway outside the exhibit and just listened to the "grind tapes" over and over. I've since met Ward Hall (1930–, born Ward Hall in Trenton, Nebraska; Mr. Hall is a sideshow owner, talker, juggler, magician, fire-eater, sword-swallower) and Bobby Reynolds (1937–, born Robert Reynolds in Jersey City, New Jersey; Mr. Reynolds is a sideshow owner, talker, juggler, magician, fire-eater, sword-swallower, flea circus talker). Ward and Bobby are the two brilliant talkers who did most of those tape loops that I memorized as a child. "Thalidomide, the day a woman's world stood still…," "The horrors of drug abuse…," "Fun, fun, fun, watch them laugh as they come out." You can hear these haunting, powerful American recordings in the Smithsonian's collection,

and I'm sure you can find them online. When I was a child, I heard them just once a year over and over and over, for four days on a midway at our small town fairgrounds. I stood there listening for hours, afraid to pay my 75 cents and go in. I was afraid of what I'd see. I would listen outside and my heart would pound.

I remember finally getting up the nerve to go in and see "The World's Smallest Couple." My memory is not very detailed; it's mostly just feelings. I should call Ward Hall and ask him what little people would have played Greenfield in 1970. I should find out who they were and what they did. I don't remember them doing anything. I don't remember what they looked like. I do remember I was shaking and scared. Beyond that, all I remember is that there was a little woman, and next to her was a little man. The little man was eating an apple. He was eating an apple. My nightmare, my worry, my disgust, my horror, the object of my titillation and pity—my future—was standing eating an apple. He was about the age of my dad. He was clean shaven like my dad. He wore a shirt and tie like my dad always wore, even sitting around at home eating an apple. The little man was eating an apple, just like my dad ate an apple. I don't remember what the performer's face looked like, but I remember the sound of the apple crunching and the chewing. He sounded just like my dad. As you read this book, notice how many of the performers do

shows that include everyday things like shaving, writing, and smoking a cigarette, just like the audience.

I've looked at photographs of most of the people in this book. I've lived with some of them. I have an original photograph of "The Great Waldo" swallowing a live mouse on the wall of my home. My very good friend, mentor, and hero is Johnny (1934–, born John Thompson in Chicago, Illinois; Mr. Thompson does a comedy/magic act with birds, and with a bowling ball with his wife, under the name "The Great Tomsoni and Company"). Johnny works with us helping us design, direct, and write magic tricks for the Penn & Teller show. Johnny worked on a sideshow with The Great Waldo. Johnny tells stories about working with Waldo. Johnny also tells stories of working with Shecky Greene and Lenny Bruce.

Why would anyone draw caricatures of freaks? How amazing is it for a man to have three legs in a drawing or even a photograph? You have to see that extra leg live on the inside, right? But these drawings are not supposed to be proof. We trust the facts. The important parts of Drew's drawings are not the extra leg, or the tiny pointed heads, or the folds of fat or loose skin. The images in these pictures that kill me deader than a doornail up Melvin Burkhart's nose are the parts where these human beings are just eating an apple while we stare at them. We want to look at them because they're different from us, but we

keep looking at them because they're the same as us. No one is better at capturing what makes us all the same than Drew (1958–, born Drew Friedman in New York, New York, who works as a cartoonist under the name Drew Friedman). Drew's drawings of Frank Sinatra, Jerry Lewis, Tiny Tim, Milton Berle, Leo Gorcey, Shecky Greene, Barack Obama, and William Frawley show these icons with all the little imperfections that bring them back from legends to human beings. This book with all its beauty brings the freaks back to just as human as Drew's Sinatra. Drew reminds us that we're just staring at each other.

Billy West (1952–, born Richard William West in Detroit, Michigan; under the name "Billy West" he became one of the most successful voice character actors of all time and is the voice of Philip J. Fry on *Futurama*, Stimpy on *Ren and Stimpy*, the red M&M, Elmer Fudd, etc., etc.) once said that there was only one show business. Yup, and Billy, Drew, me, Picasso, Bach, the mall Santa, and Koo Koo the Bird Girl are all in that business. Drew reminds us that beyond that, there's only one human race and we're all part of it.

Now, let's stare at people.

Penn Jillette (1955–, born Penn Fraser Jillette in Greenfield, Massachusetts; Mr. Jillette has worked in the comedy/magic team with his partner, Teller, for all of his entire adult life)

John Eckhardt Jr. (1911–1991, Baltimore, MD), Johnny Eck, billed as "The Most Remarkable Man Alive" and "The King of the Freaks," was born without a body below his waist and learned to walk on his hands. He enjoyed a long career touring as a famed sideshow performer and was memorably featured as the "Half Boy" in the classic Tod Browning film *Freaks* (1932). He also conducted an orchestra in his hometown of Baltimore with his "normal" twin brother, Robert, on piano.

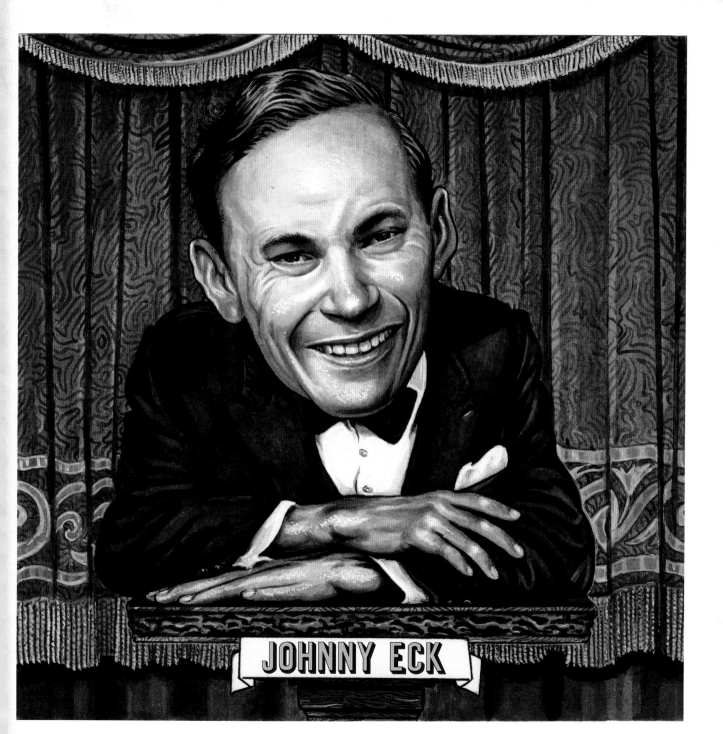

JOHNNY ECK

Simon Metz (1901/possibly 1891–1971, Bronx, NY, or Santa Fe, New Mexico), known as "Schlitzie," "What Is It?," and "The Last of the Aztecs/Incas," was born microcephalic, resulting in a small brain and head, a height of only about four feet, and the cognition of a three-year-old. Schlitzie was dressed in colorful dresses or muumuus, purportedly due to incontinence, making it easier for his handlers to change his diapers but giving many the impression that he was female. Head shaved and sporting a bow, Schlitzie became one of the most famous and beloved sideshow performers in history. He delighted audiences for decades with his singing and dancing; banging on the piano; card tricks; silly, infectious monosyllabic talk and giggling, memorably captured by Tod Browning in *Freaks* (1932), in which he's referred to as "she." Schlitzie (and "Zip") were the inspiration for Bill Griffith's iconic cartoon character "Zippy the Pinhead."

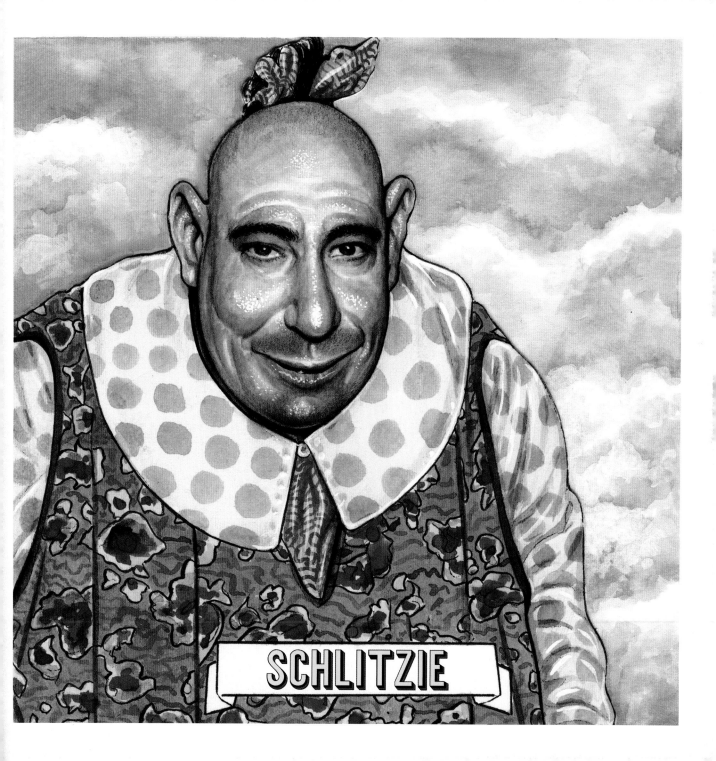

Aurora & Natali (birth names, life spans, and birthplace unknown), "The Aztec Pinheads" (shown here with their manager, Max Klass), were exhibited together as children and traveled with various circus sideshows in the early twentieth century. Both were outfitted in traditional loose-fitting Central American serapes, each displaying the ancient religious symbol of the swastika on the front.

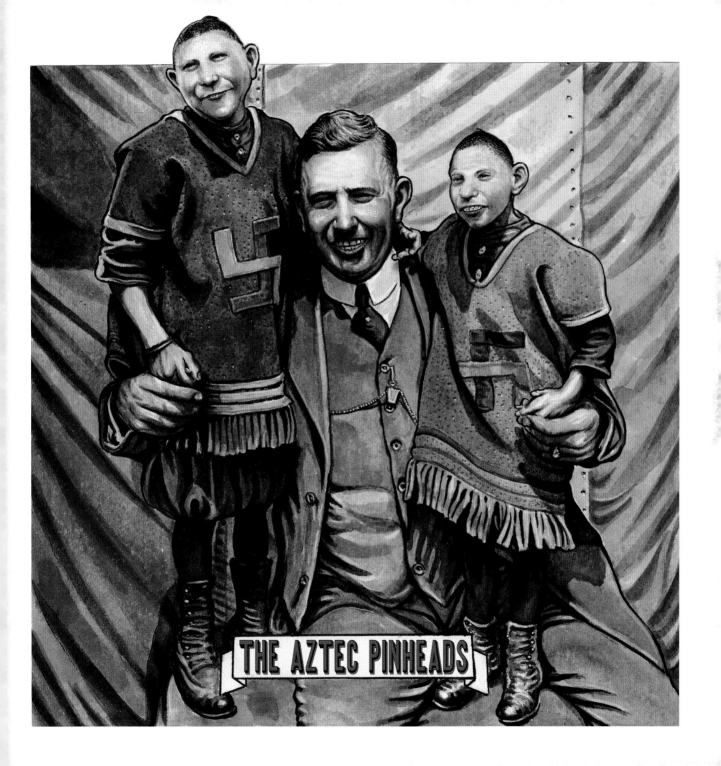

THE AZTEC PINHEADS

Leo Kongee (life span unknown, Pittsburgh, PA), known as "The Human Pin-Cushion" and "The Human Blockhead," was a performer at the Believe It or Not show at the 1933 Chicago Century of Progress International Exposition (World's Fair) Odditorium, billed as the "human pincushion whose skin never bleeds and seems immune to torture." His nerves did not register pain, nor did he bleed as he punctured his tongue and cheeks with hat pins and pounded forty small spike nails into his nose.

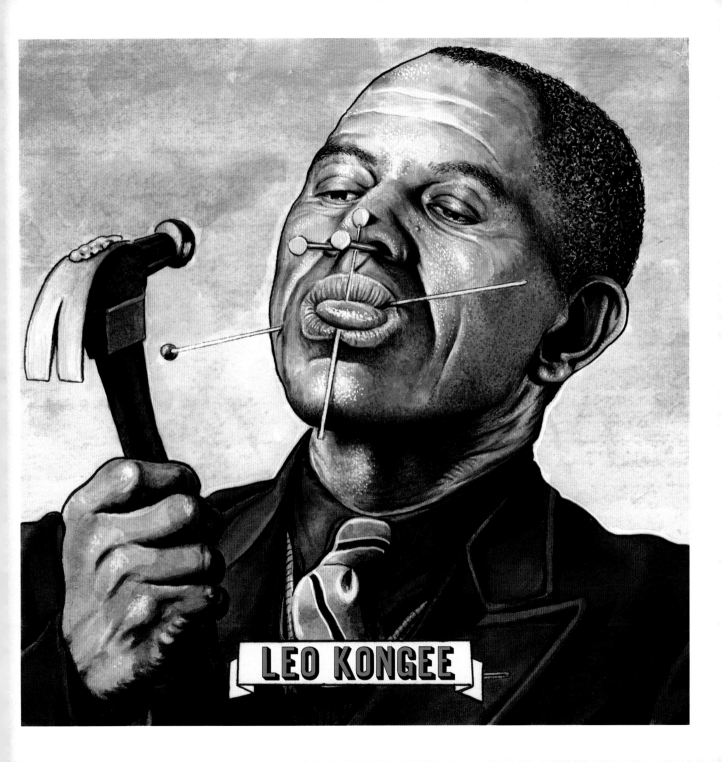

LEO KONGEE

Eddie Carmel (1936–1972, Tel Aviv, Palestine), "The Jewish Giant" (shown here with his promoters at the time), moved with his normal-sized parents to the Bronx when he was a small child and eventually grew to a height of 7 feet, 6³⁄₄ inches, leading to his interest in pursuing a career in showbiz. He primarily appeared in carnival sideshows throughout the 1960s, including Ringling Brothers and Hubert's Museum. He also made a brief appearance in the 1962 cult horror film *The Brain That Wouldn't Die* as the giant mutant pinhead who emerges from the closet during the climax. He was photographed in 1970 with his parents by Diane Arbus in their small Bronx apartment.

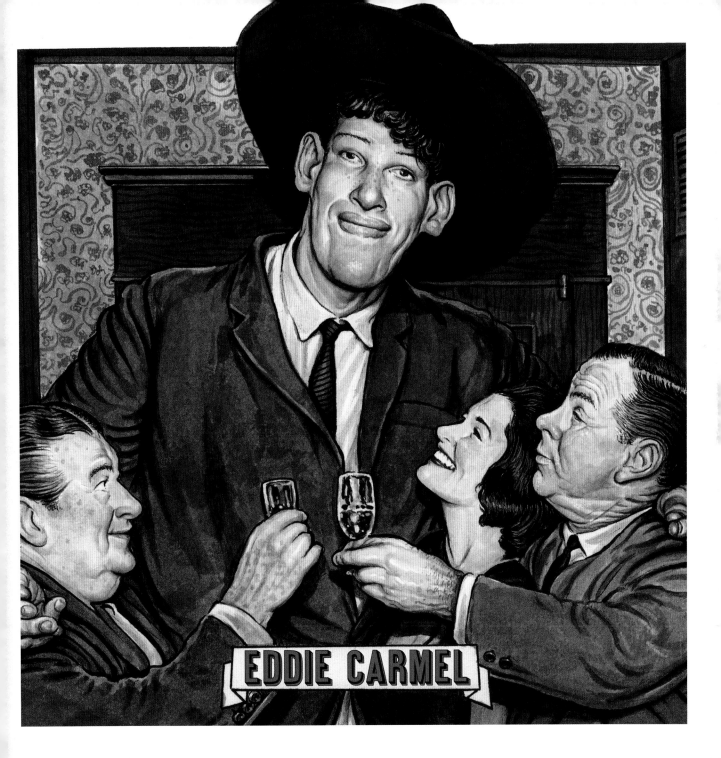

EDDIE CARMEL

The Doll Family—Grace (Frieda Schneider, 1899-1970), Harry (Kurt Schneider, 1902-1985), Daisy (Hilda Schneider, 1907-1980), and Tiny (Elly Schneider, 1914-2004)—(Stolpen, Germany), were a performing group of four dwarf siblings (of a family of seven children, three of normal size), who appeared for decades in circuses and sideshows in the United States, as well as in many films, as a group or solo, including *The Wizard of Oz* (1939), in which Harry was cast as one of the boys of the "Lollipop Guild." Tod Browning directed him costarring with Lon Chaney in *The Unholy Three* (1925). Harry is credited with introducing Browning to the short revenge story "Spurs," the basis for the movie *Freaks* (1932), in which three (Harry, Daisy, and Tiny) of the Doll Family siblings were cast.

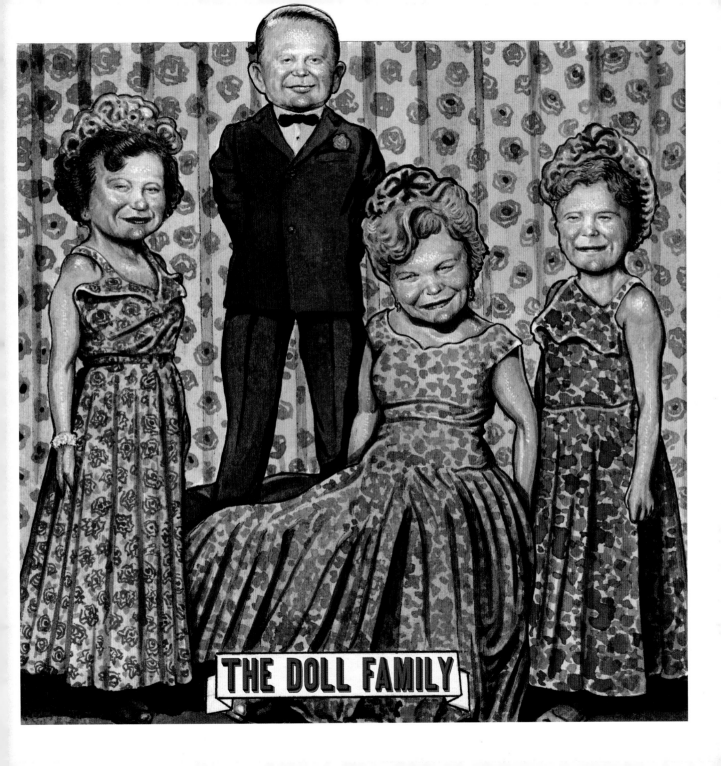

Grady Stiles, Jr. (1937–1992, Pittsburgh, PA), known as "The Lobster Boy" and "The Lobster Man," was born with ectrodactyly, a deformity that gives the appearance of lobster-claw malformation of the hands and feet. Grady was the fifth in his family with the same hereditary deformity, including his father, a sideshow attraction, who added him to the show at age seven as "The Lobster Boy." Stiles Jr. later toured as "The Lobster Family" with his son Grady III and daughter Cathy (the two of his four children also born with ectrodactyly). Unfortunately, Grady deteriorated into an abusive alcoholic, leading to tragic, murderous consequences.

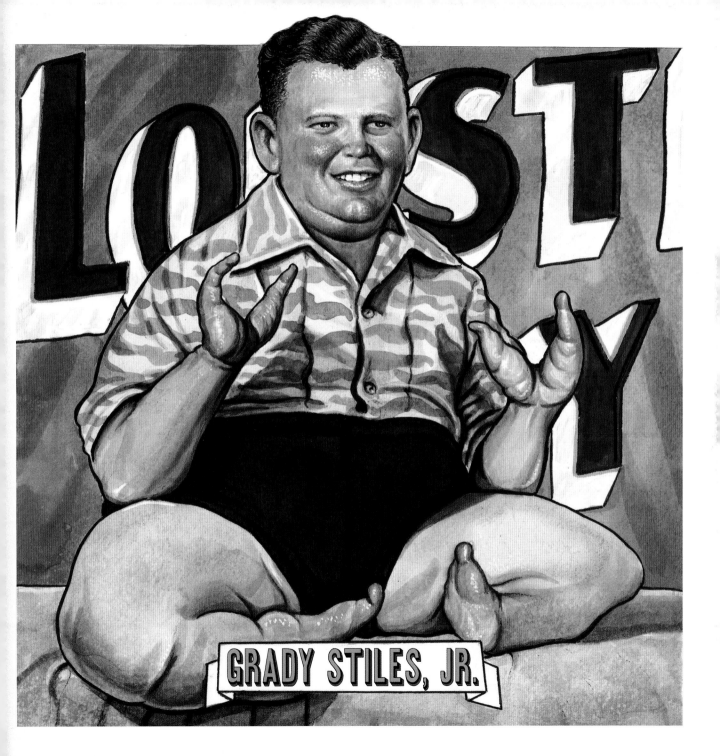

GRADY STILES, JR.

Daisy & Violet Hilton (1908–1969, Brighton, England), known as "San Antonio's Siamese Twins" and "The Texas Twins," were born as pygopagus twins, conjoined at the hip and buttocks. The sisters' birth mother, Kate Skinner, was a poor, unmarried British barmaid, who sold them at two weeks old to her landlady and midwife, Mary Hilton. Soon after Hilton "adopted" them, she realized their commercial potential and put them, at the age of three, on an exhibition tour in England and, afterward, the United States. Eventually freed from the greedy Hilton's control and, after her death, Hilton's daughter Edith's control, the sisters became musical Jazz Age sensations in vaudeville and later in movies. They appeared in *Freaks* (1932) and later played themselves in *Chained for Life* (1951), a film that mainly focused on their tumultuous, unhappy love life.

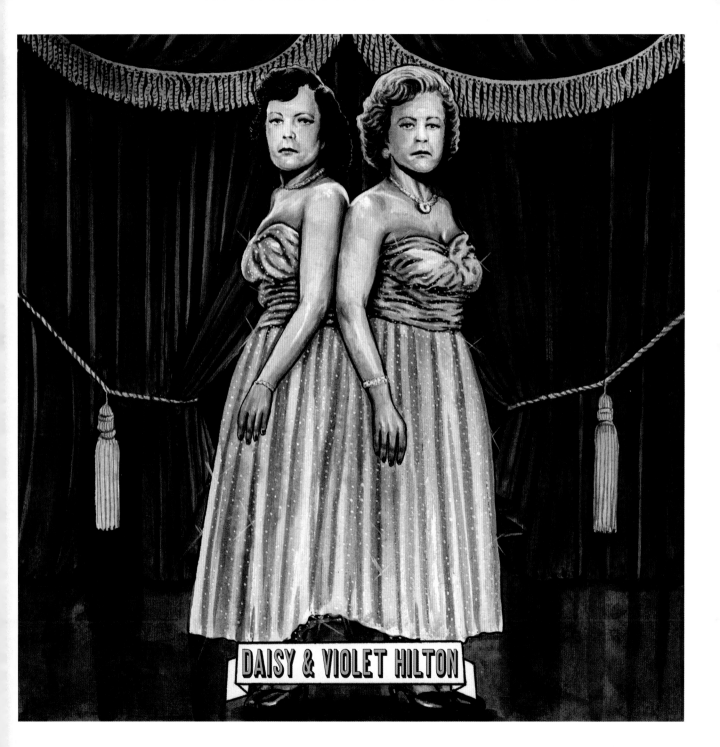

DAISY & VIOLET HILTON

George and Willie Muse (1890–1971/1893–2001, Franklin County, VA), "Eko & Iko," were billed as "The Ambassadors from Mars" as well as "The Sheep-Headed Men." Kidnapped in 1899 and told that their mother was dead, they toured with Al G. Barnes and later Ringling Brothers and Barnum & Bailey Circus. In 1927 they visited their hometown, where their mother found them and fought to free them. Engaging the services of a lawyer, they obtained a contract that permitted them to retain great profits from future sideshow exhibition, and in 1928 they returned to show business until retiring to Roanoke in 1961. Promoters alternately claimed they were "found near the remains of their spaceship" or that they were "Sheep-headed Cannibals from Ecuador." In actuality, they were dreadlocked African-American albino brothers from Virginia. Willie Muse lived to age 108.

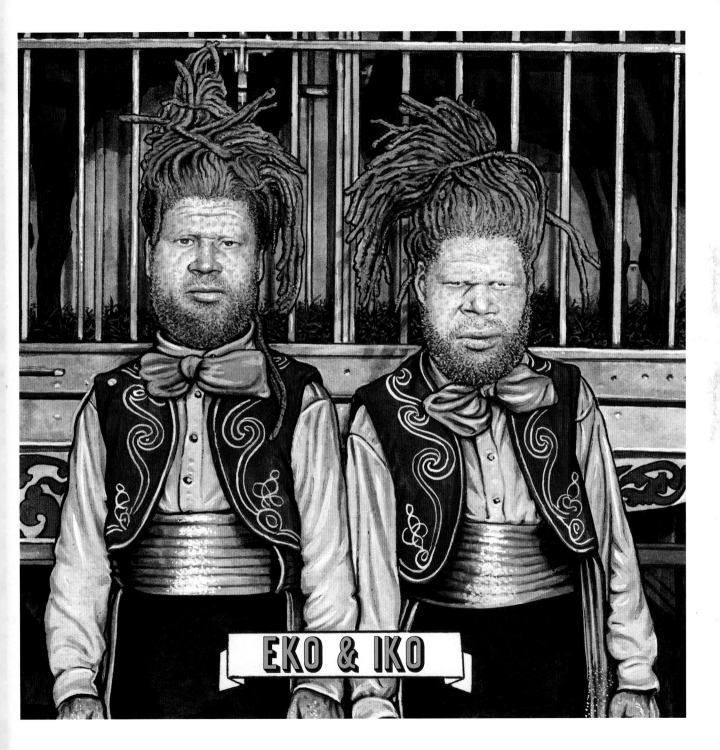

"The Wild Fat Man" (birth name, life span, and birthplace unknown) was an African-American Fat Man whose novel act consisted of wearing a furry, animal-skin loincloth, sporting a wild, wavy wig, and sitting in a jungle setting while holding a live chimp.

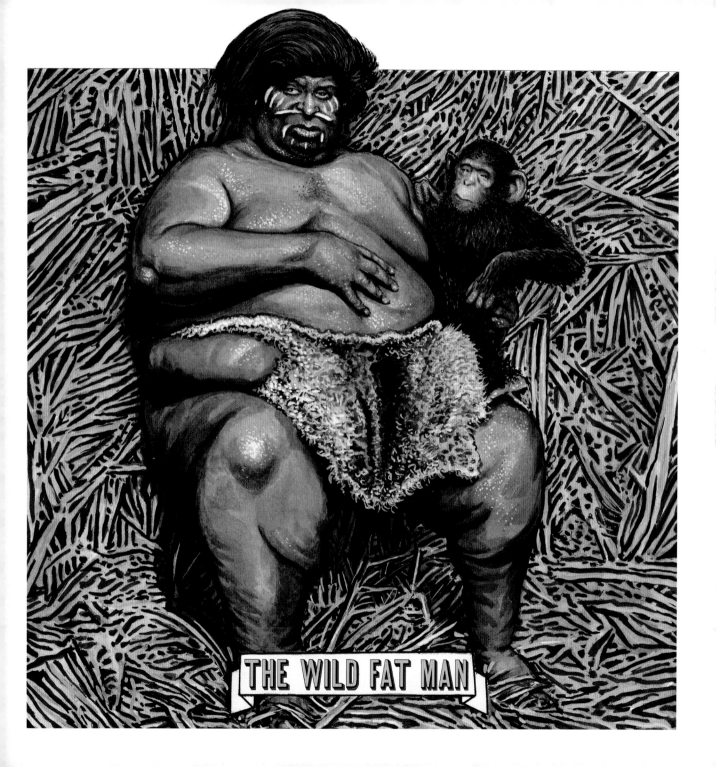

THE WILD FAT MAN

Grace McDaniels (1888–1958, Numa, IA), "The Mule-Faced Woman," was also known as the "Homeliest Woman in the World." When she would lift her veil after being introduced, several members of the audience inevitably would faint. She had a rare congenital disorder that caused a large port-wine stain on her face and thickened, distorted folds in the flesh of her face. Grace had one son, Elmer, the result of being taken advantage of by an intoxicated carnival worker. Elmer eventually managed her business affairs but became an abusive alcoholic and died the same year as his mother.

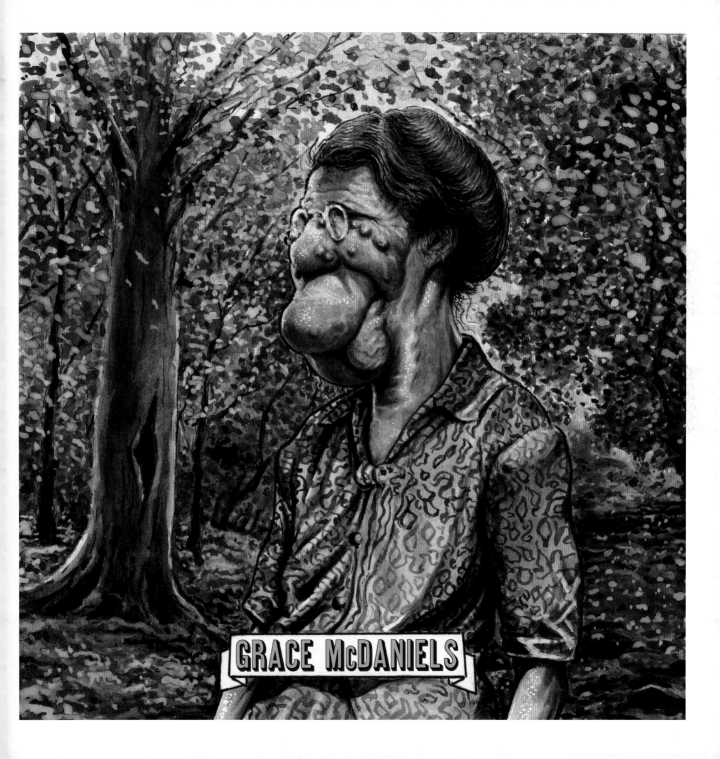

GRACE McDANIELS

Ella Milbauer (Mills) (1889–1964, Baraboo, WI) was a popular Fat Lady appearing mainly in the Ringling Brothers sideshows, billed as "586 Pounds of Feminine Charm." Ella was a crowd favorite, known for coyly displaying her massive legs to the delight of the male patrons, who rewarded her with whistles and catcalls.

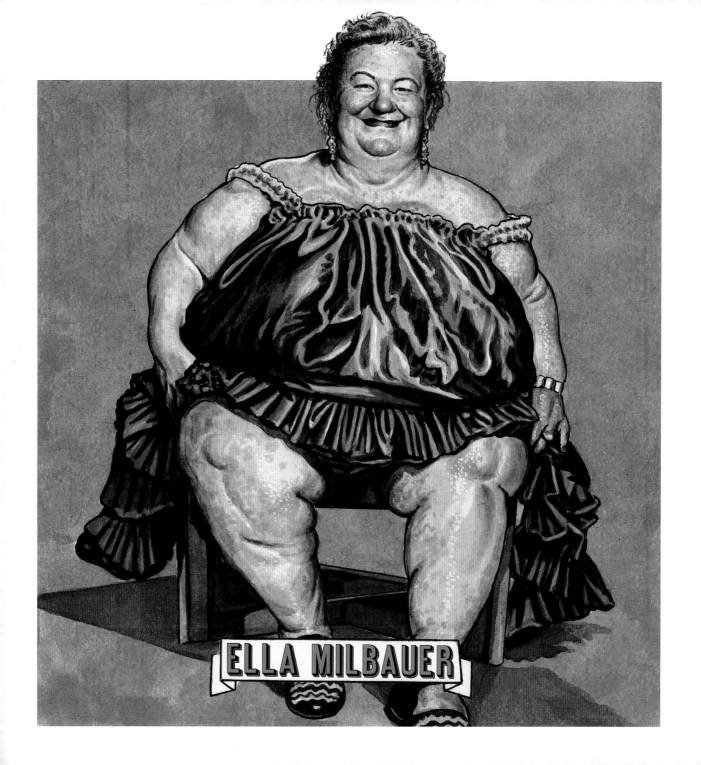

ELLA MILBAUER

"Jolly Jere" (birth name, life span, and birthplace unknown) was a lighthearted Fat Man appearing at Coney Island sideshows in the 1960s and 1970s. His weight reached well over 700 pounds and he was indeed jolly, delighting audiences with, good-humored, self-deprecating tales of how his massive weight affected his life, including how his wife finally became fed up with his weight gain and fled.

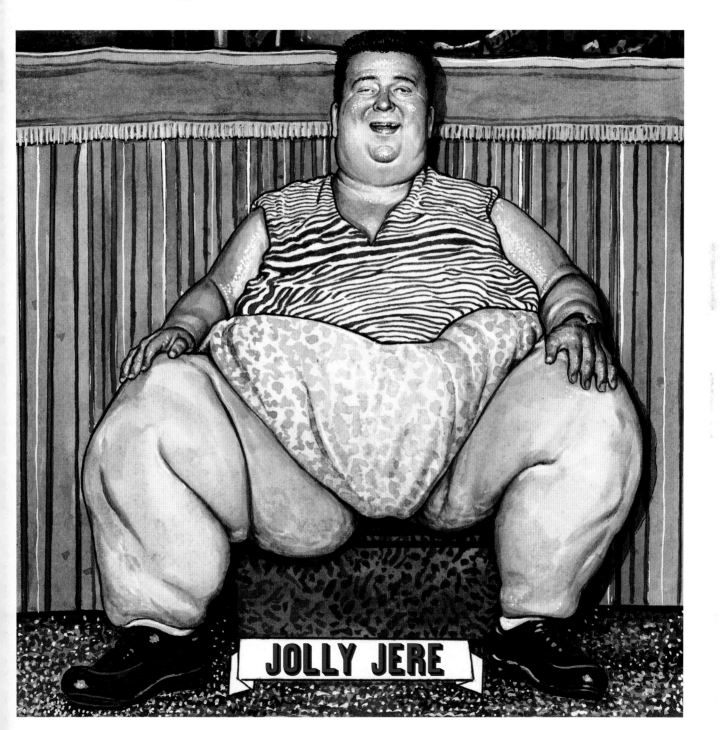

"The Windbag Man" or "The Balloon Man" ("J. W.," birth name undisclosed, 1863–1892, Philadelphia, PA?) had a colon of dimensions equal to that of a cow. At age twenty, his body was so peculiar that he was able to profit from it by being exhibited as a "freak" for the next ten years at the Ninth and Arch Streets Museum in Philadelphia. It was said that the circumference of his body was equal to his height and that he took particular delight in pounding himself upon the abdomen with his fist and inviting the spectators to do the same, to hear it resound like a drum. His colon, which was inflated to exactly the proportions as found at the autopsy and dried, is on display at the Mütter Museum in Philadelphia.

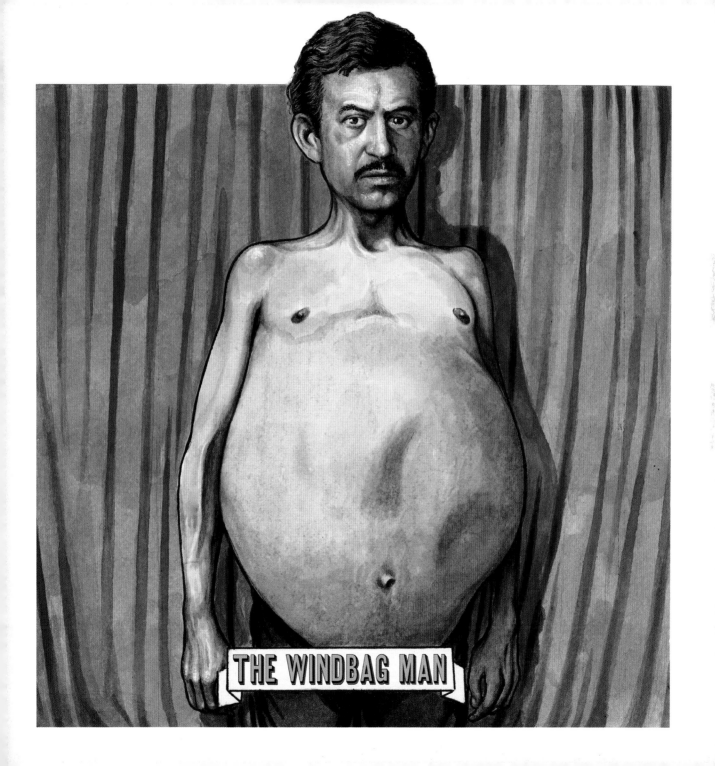

Melvin "Twisto" Smith (life span and birthplace unknown), "The Man with the Rubber Bones," was a performing contortionist, able to bend, twist, and flex his body into unnatural positions. His main skill was dislocation of the shoulders. He performed at the Believe It or Not show at the 1933 Chicago Century of Progress International Exposition (World's Fair) Odditorium, among other venues.

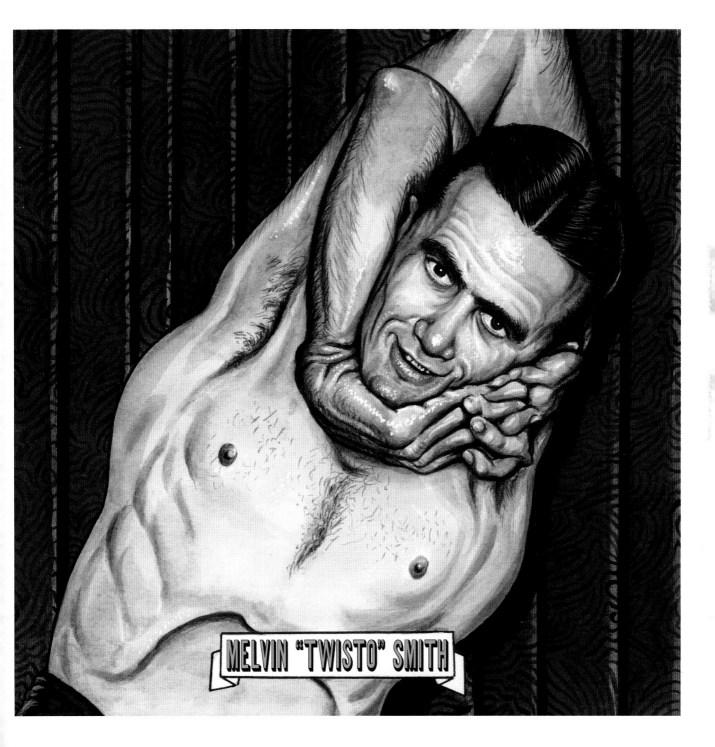

Melvin Burkhart (1907–2001, Atlanta, GA), known as "The Anatomical Wonder" and "The Human Blockhead," was a legendary, much-beloved sideshow performer for more than sixty years. Taking advantage of having had his nose often broken as a boxer, he could hammer nails and spikes up his nostrils. Employing his unusual ability in muscle control, he could elongate his neck, suck his stomach into his spine, wrestle snakes, and exhibit opposite expressions on his face simultaneously—happy and sad or, as he described it, "mad and glad at the same time." Melvin acted as his own announcer ("talker"), much in the style of a Borscht Belt comic, swearing throughout his performances that it didn't hurt.

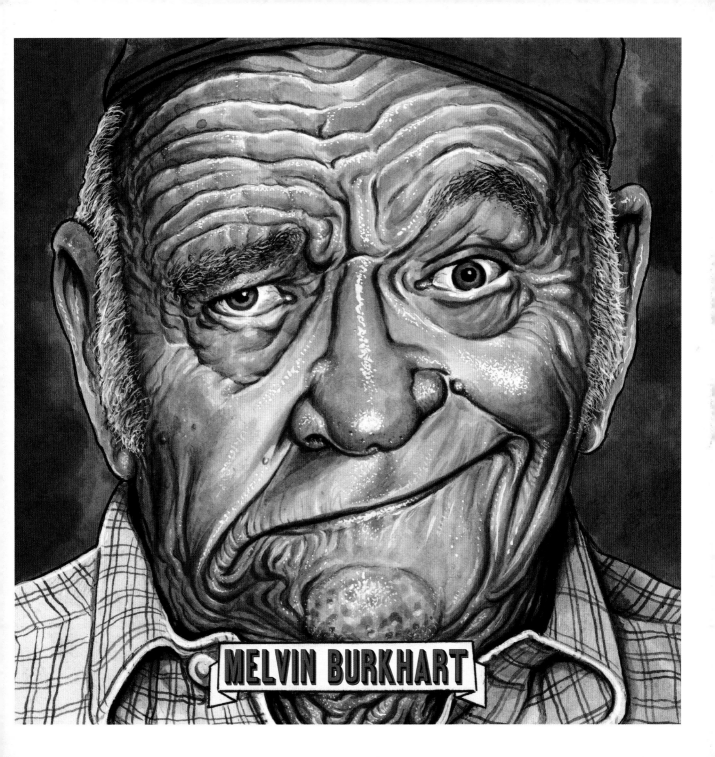
MELVIN BURKHART

Sam Alexander (c. 1920s-1997, Chicago, IL), "The Man with Two Faces," was involved when a young man in a huge gasoline explosion due to his own carelessness of throwing a lit cigarette into a gasoline drum. Although he covered his eyes, his face was essentially burned off, resulting in a permanent gruesome appearance. After taking time to recover, the ambitious Sam eventually joined a sideshow, where he would begin his act by wearing a lifelike mask while calmly relating his sad story to the audience. His tale told, he would turn away, quickly remove the mask, and turn back to the screaming, sobbing, and fainting of the audience.

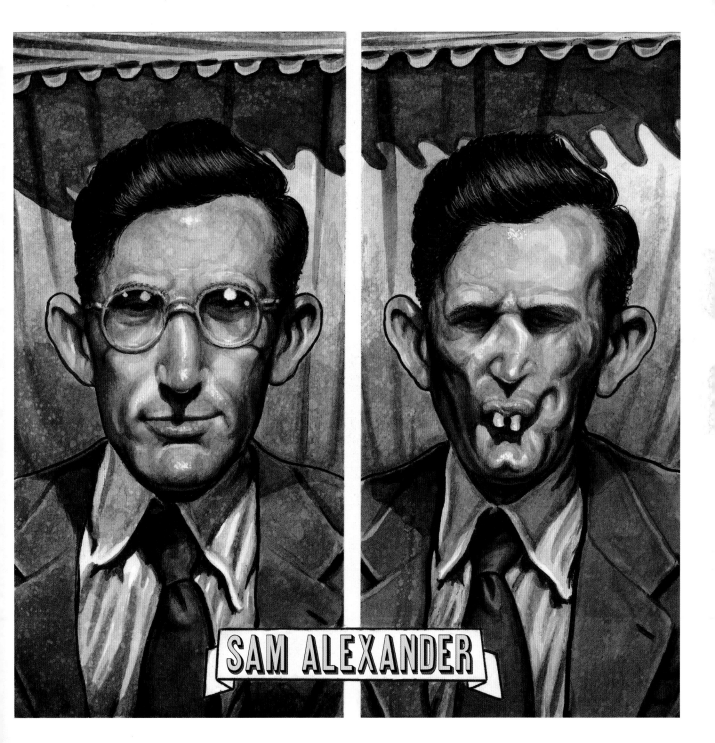

SAM ALEXANDER

"The Man Who Would Be Popeye" (Robert Everhart, life span and birthplace unknown) was able to contort his face to resemble the famed cartoon character. Sporting a corncob pipe and sailor outfit, he appeared in the Believe It or Not show at the 1933 Chicago Century of Progress International Exposition (World's Fair) Odditorium, the same year the cartoon character made his movie debut. *Billboard* magazine of September 6, 1947, reported that after ten years performing Popeye characters on the night club circuit and three seasons in the Ripley's show at the Chicago World's Fair, Everhart underwent surgery in 1946 in a military hospital in Sapporo after serving as a major in Japan. The operation removed a growth on his jaw caused by the many dislocations, bringing an end to his performing career.

ROBERT EVERHART

Peter Moore (1932–1984, Wetumpka, AL) was billed as "The World's Smallest Man," standing 27 inches and weighing 32 pounds. He was the oldest of nine (normal) brothers and sisters, and enjoyed a long, happy career performing at various carnival and state fair sideshows

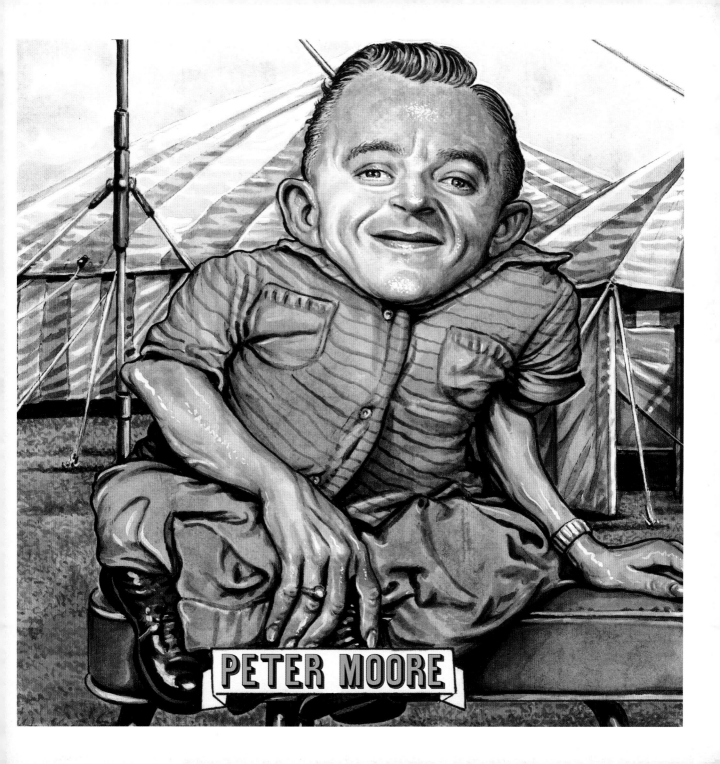

PETER MOORE

Paul Rodriguez (1920–?, Madrid, Spain), known as "The Smallest Man in the World," along with his two dwarf sisters, Trinidad and Dolores, were billed as "The Three Del Rios." They were first exhibited in Mexico, before arriving in America to appear as Munchkins in *The Wizard of Oz* (1939). Paul, the smallest of the siblings, grew to a height of 19 inches and a weight of 12 pounds.

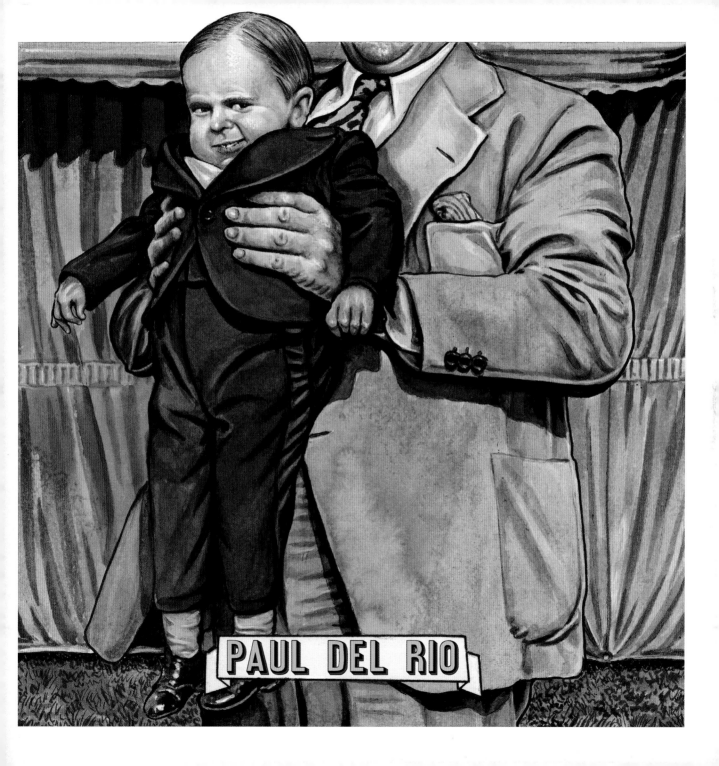

PAUL DEL RIO

Robert (Bob) Melvin (1920–1995, Lancaster, MO), known as "The Man with Two Faces," had neurofibromatosis, a disorder that causes the spontaneous growth of fibrous tumors. The left side of his face, however, was completely normal—thus his sideshow moniker. Melvin was a hugely popular sideshow attraction for decades, beginning at Coney Island, yet he also managed to live a very happy, "normal" life, marrying his high school sweetheart and eventually running a hardware store and regularly attending church in his hometown, where he was loved and accepted by all. He also appeared, sans makeup, in three 1970s horror films, *The Other Sisters* and *The Sentinel*

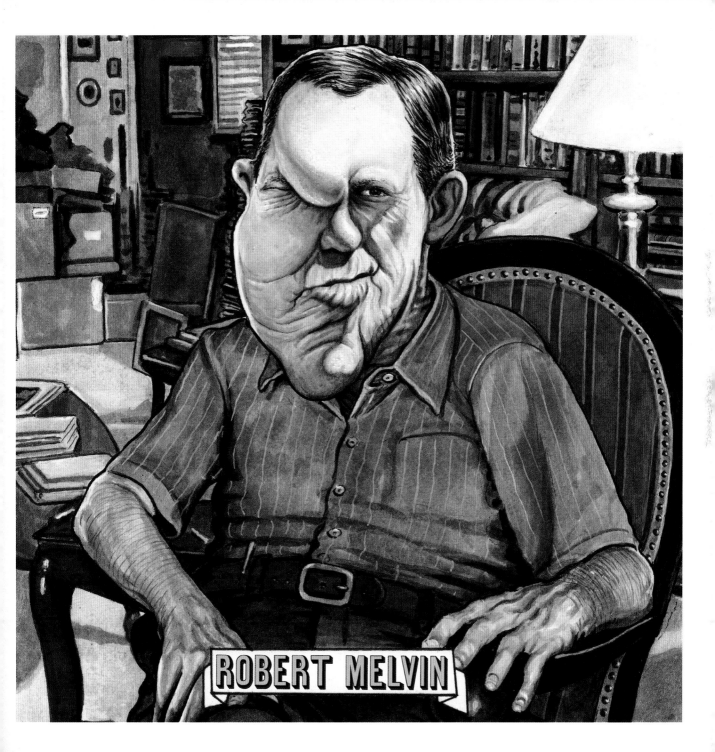

ROBERT MELVIN

Jack Earle (Jacob Erlich) (1906–1952, Denver, CO), "The Texas Giant," was known as one of the tallest humans of his day, standing at 7¾ feet (although advertised as 8 feet, 6 inches). He achieved great success in Hollywood in the 1920s, appearing or starring in dozens of silent film comedies. A freak accident abruptly ended his movie career but led to a fourteen-year association with the Ringling Brothers Circus, where he was billed as "The Tallest Man in the World," a claim he helped exaggerate by wearing tall-heeled cowboy boots and a giant ten-gallon hat.

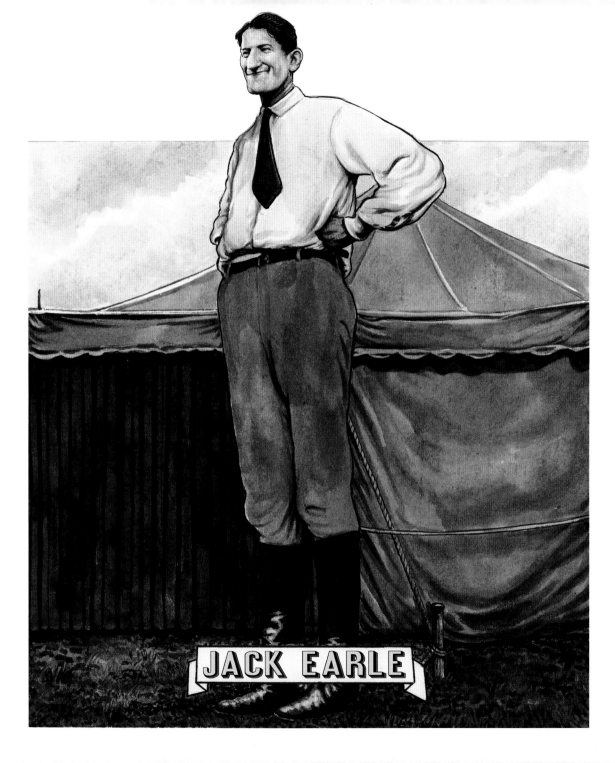

Celesta Herrmann Geyer (1901–1982, Cincinnati, OH), "Dolly Dimples," did not suffer from glandular problems; she simply liked to eat. A lot. She eventually joined a sideshow and was billed as "The World's Most Beautiful Fat Lady." She ballooned to 555 pounds before suffering a near-fatal heart attack, which inspired her to lose 443 pounds rapidly and become a dedicated diet guru, writing an autobiographical book, *Diet or Die*, published in 1968, and advocating exercise and healthy eating.

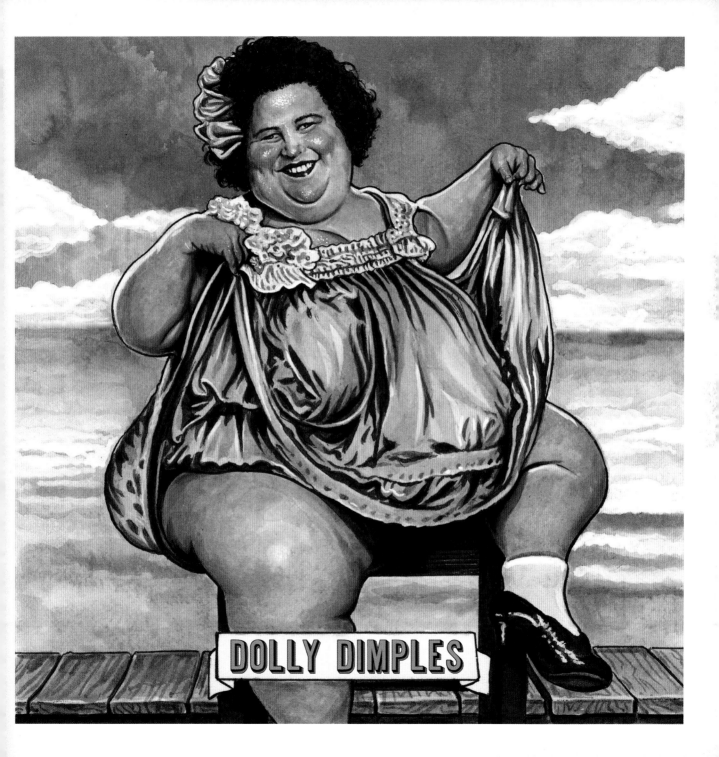

A. Reinold (life span and birthplace unknown) was yet another sideshow Fat Man. The legendary promoter and "King of the Sideshows" Ward Hall once commented, "In today's world, a fat person won't sell in a sideshow. There's just too many of them and nobody wants to pay to see one."

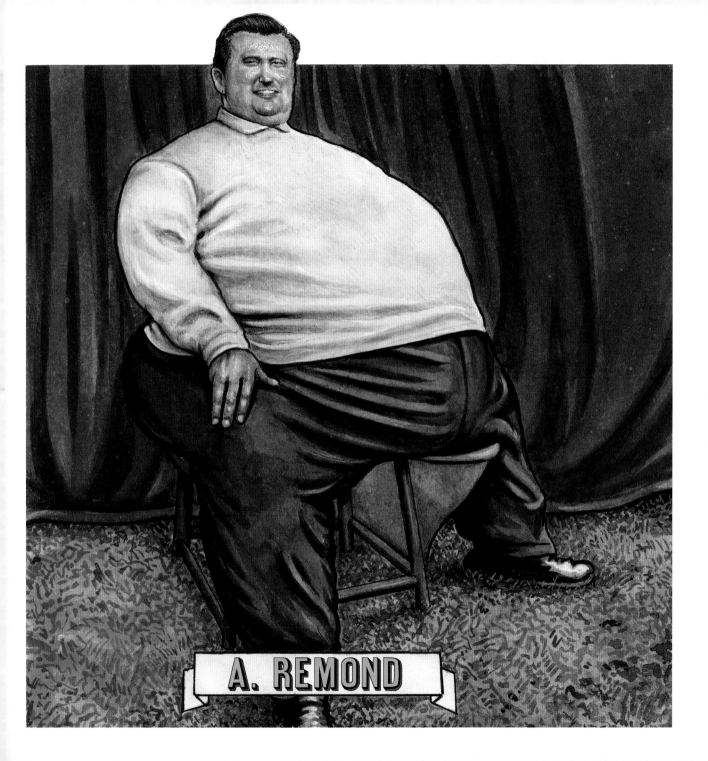

Peter Robinson (1874–1947, Springfield, MA), "The Living Skeleton," was a popular 58-pound carnival sideshow Thin Man who in the mid-1920s married his longtime love, 467-pound Fat Lady "Baby" Bunny Smith, in a large, well-publicized ceremony at Madison Square Garden in New York. At the time, they were both performing their dancing act for the Ringling Brothers Circus. He also appeared as the "Human Skeleton" in *Freaks* (1932), as the husband of the bearded "Lady Olga."

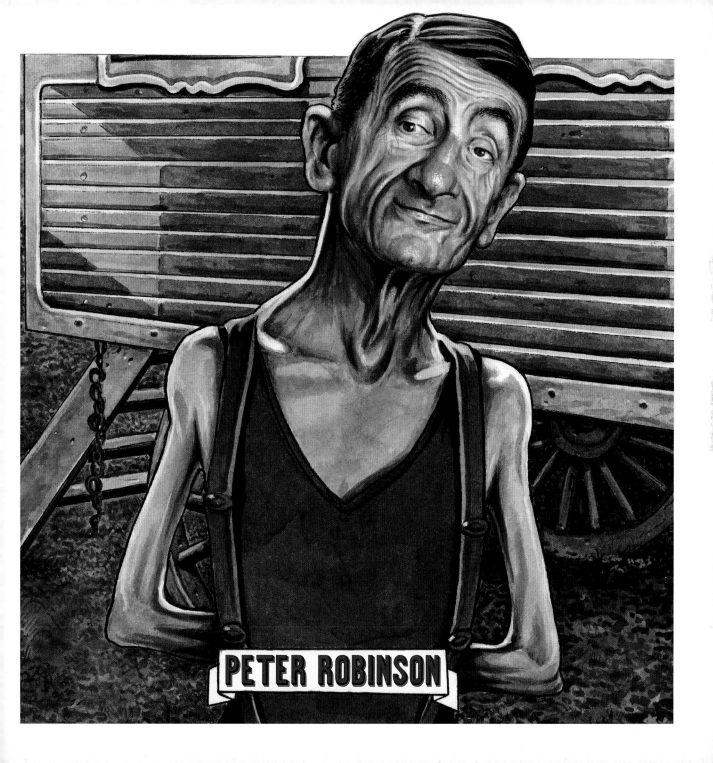

Jane Barnell (1877–1951, Wilmington, NC), "Lady Olga Roderick," began to grow facial hair soon after birth. Disturbed by the child's beard, her mother sold her four-year-old daughter to a traveling circus sideshow showman while her husband was away on a business trip. Jane went on to have a long career as a Bearded Lady in various circus sideshows and dime museums. Her beard would eventually reach 13 inches, and she was later cast in *Freaks* (1932), a film she would regret appearing in, often referring to it as "insulting."

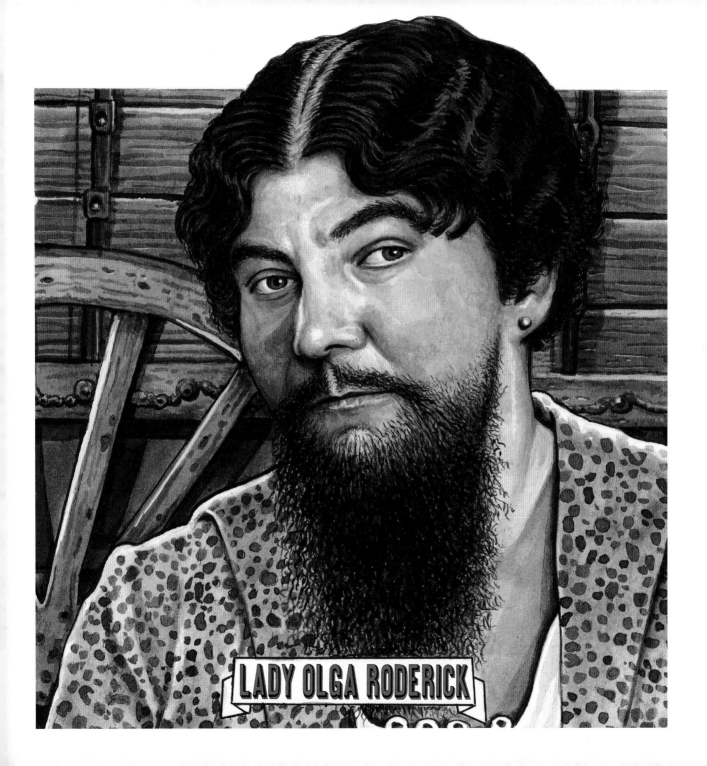

LADY OLGA RODERICK

Mary Ann Bevan (1874–1933, Plaistow, London, England) was billed as "The Homeliest Woman in the World." She began to show signs of acromegaly around the age of thirty, Seeking to support her family of four children after her husband died in 1914, she entered and won an "Ugly Woman" contest, leading her to a career as a popular sideshow attraction throughout the 1920s, mainly at Coney Island's Dreamland sideshow.

MARY ANN BEVAN

Percilla Lauther Bejano (1918–2001, Bayamón, Puerto Rico), aka "The Monkey Girl," was born with hypertrichosis, a condition that covered her head, face, and body in silky black hair, and she had two rows of teeth. At age five she had been brought by her parents to New York for medical examination when her father decided to exhibit their daughter for profit in sideshows. Percilla sang and danced and performed with a trained cigarette-smoking chimpanzee named Josephine. When she was twenty, Percilla met Emmitt Bejano, a fellow sideshow performer known as the "Alligator Skin Man," due to his ichthyosis, a congenital skin disease that causes thick, scaly skin. They fell in love, married, and later toured as "The World's Strangest Married Couple." They remained lovingly devoted to each other for more than fifty years.

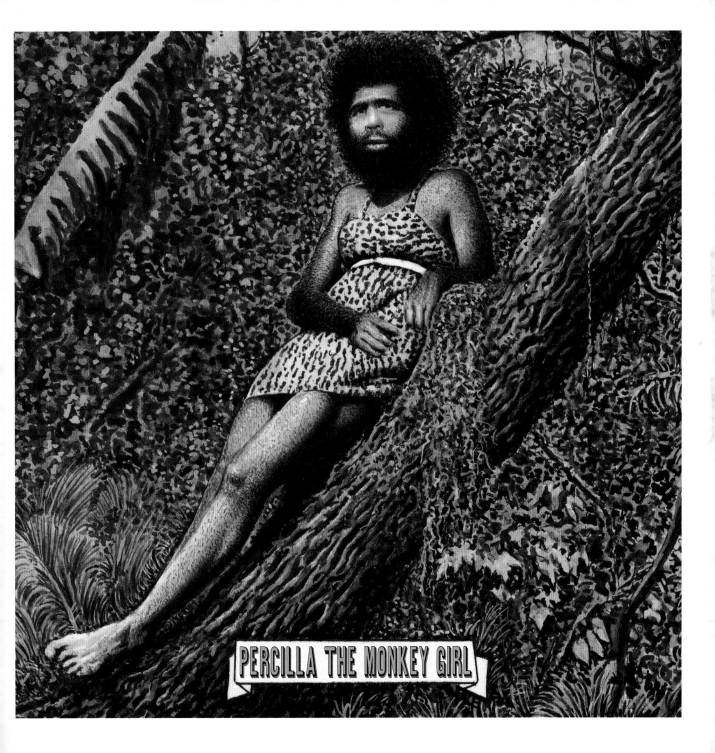

PERCILLA THE MONKEY GIRL

Gondino Rao and Lukshana Bai (c. 1895–?/c. 1906–?, Lower Burma, India), known as "Gondino & Apexia," both appeared with the Ringling Brothers Circus in the early twentieth century and were billed together as "The Pinhead Brother & Sister from Lower Burma." Gondino also appeared solo as "The Boy with the Monkey's Head" and "The Missing Link."

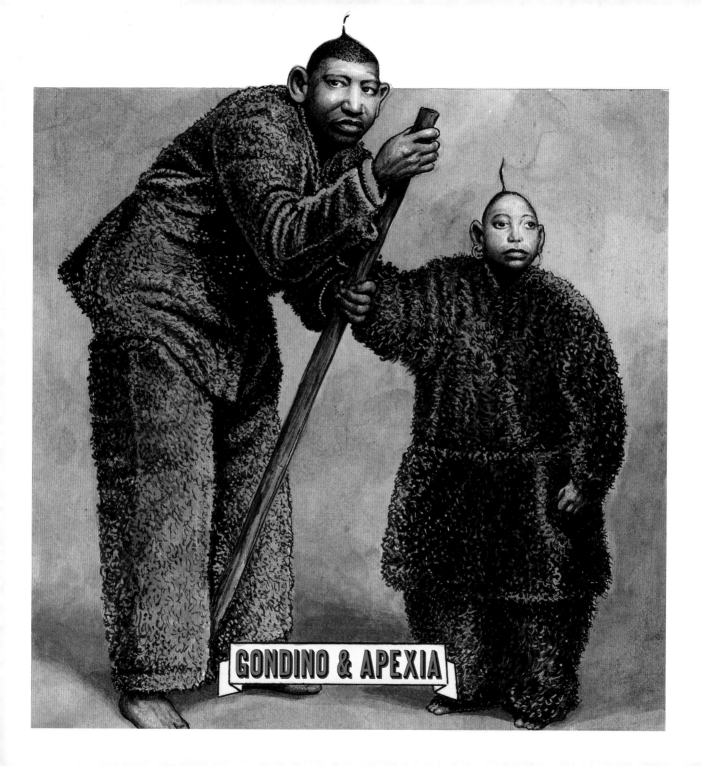

GONDINO & APEXIA

Chang and Eng Bunker (1811–1874, Meklong, Siam [Thailand]), known as "The Siamese Twins" and "The United Brothers," were the legendary xiphopagic conjoined twin brothers whose condition and birthplace led to the term (regardless of nationality) *Siamese twins*. They were joined at the sternum by a small band of cartilage, and their two livers were connected. Chang & Eng were first exhibited in England, and then in America, where they would remain and become famous, including being photographed by Mathew Brady. They earned enough to retire at age twenty-eight from exhibition and to purchase 150 acres and become gentlemen farmers in North Carolina (replete with twenty-eight slaves by 1860). In 1843 they married sisters Adelaide (Chang) and Sarah "Sallie" (Eng) Yates and produced twenty-one children between them. Chang & Eng were autopsied at the Mütter Museum in Philadelphia (in its first location at 13th and Locust Streets, since demolished); their fused livers were preserved and are on display at the Mütter Museum.

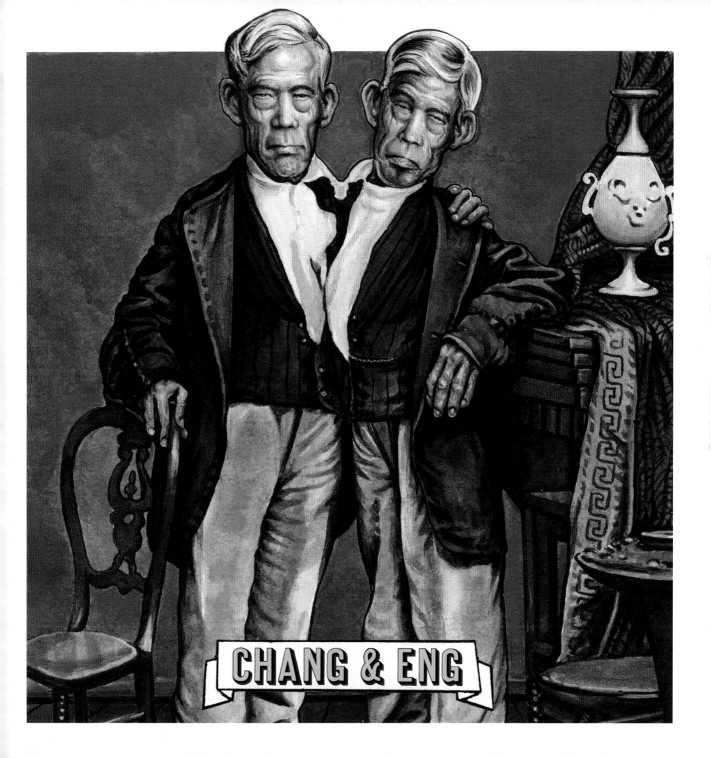
CHANG & ENG

Ronnie and Donnie Galyon (b. 1951, Dayton, OH) are omphalopagic conjoined twins and are the oldest (still) living nonseparated male conjoined twins. They began appearing when young children as Siamese twins at various United States sideshows, carnivals, and traveling shows into the early seventies; they eventually toured Latin America before retiring in the early 1990s.

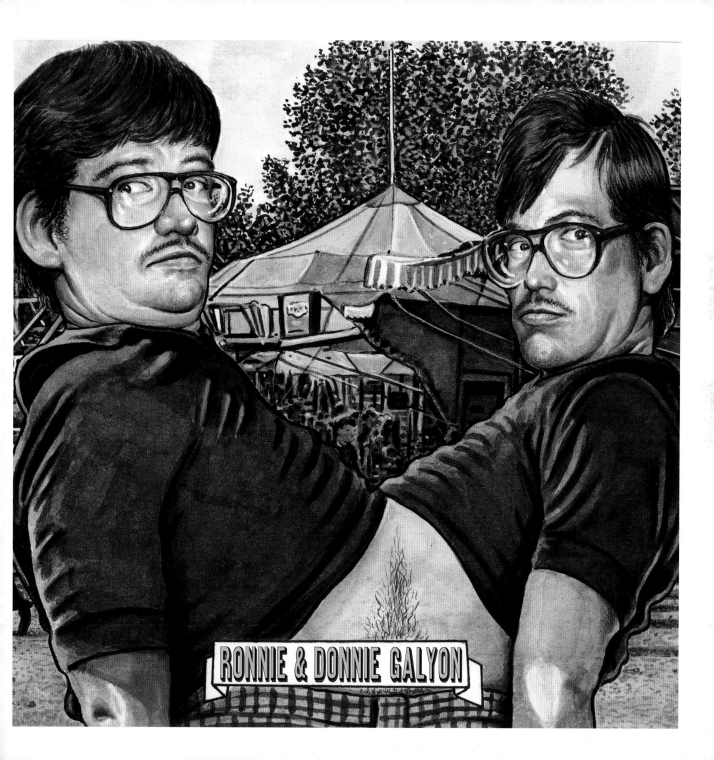

RONNIE & DONNIE GALYON

Francesco Lentini (1889–1966, Rosolini, Sicily), known as "The Three-Legged Wonder" and "King of Freaks," was born with three legs, two sets of functioning genitals, sixteen toes, and a forth small foot connected to the third leg, all that comprised his parasitic (unequal conjoined) twin. "Frank" moved to America as a young boy and soon entered the sideshow business, joining the Ringling Brothers Circus as "The Great Lentini" and touring as well with Buffalo Bill's Wild West show. He enjoyed a successful fifty-year sideshow career, marrying along the way and having four (normal) children.

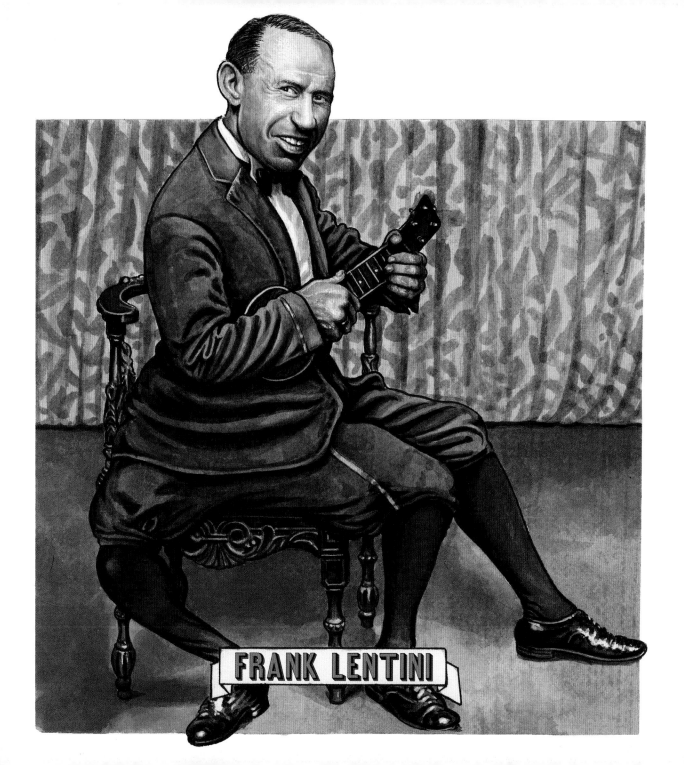

FRANK LENTINI

Otis Jordan (1925–1990, Barnesville, GA) was billed as
"The Frog Boy" and later "The Human Cigarette Factory."
Born with bent, crooked, ossified joints from arthrogryposis
multiplex congenita (AMC), he developed a skill for rolling
and lighting a cigarette using only his lips and mouth.
Otis loved his career as a sideshow performer and was still
appearing at Coney Island as late as 1990.

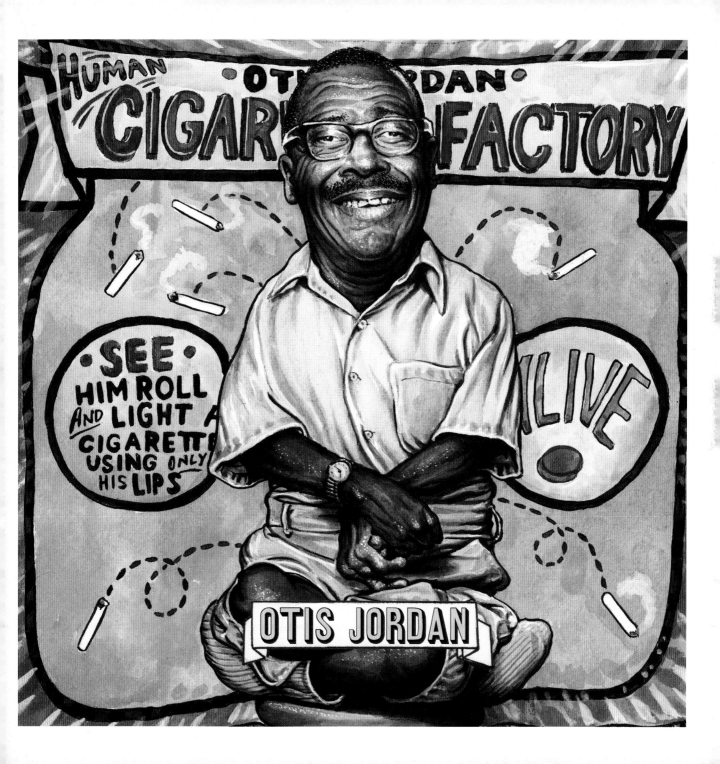

Robert Curtis (life span unknown, Tampa, FL), "Slim Jim," was a popular sideshow Thin Man or Skinny Man. Always nattily dressed in a tux and top hat, he stood 6 feet, 4 inches, and fully clothed weighed 89 pounds. In the early 1930s, Robert married 540-pound Fat Lady "Big" Bertha Curtis.

ROBERT "SLIM JIM" CURTIS

Julia Pastrana (1834–1860, Mexico), known as "The Nondescript," "The Ape Woman," and "The Ugliest Woman in the World," was a Mexican Root-Digger Indian with a severe case of congenital hypertrichosis with terminal hair, causing her face and body to be covered with thick, bristly, jet-black hair. She stood 4 feet, 6 inches and weighed 120 pounds; her nose, ears, and lips were unusually large and deformed due to severe gingival hyperplasia, giving her the appearance of having a double row of teeth. She began her sideshow career when she was discovered in 1854 by an American named M. Rates, who brought her to New York and exhibited her at the Gothic Hall on Broadway. Described as intelligent and good-natured, Pastrana became hugely popular and toured the world, entertaining audiences with graceful dancing and singing in a beautiful mezzo-soprano voice.

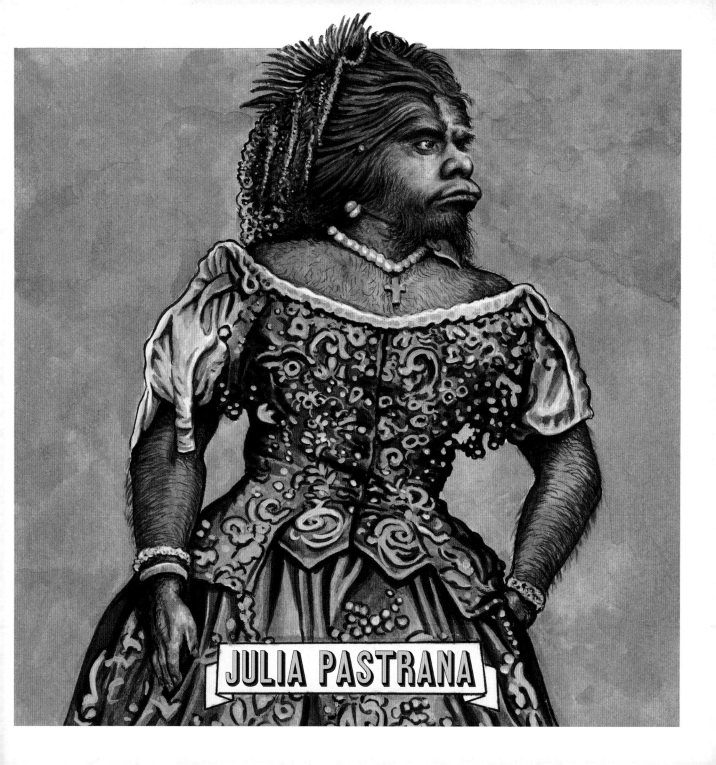

Leonard Hanstein (life span unknown, Oklahoma City, OK, active 1930s), "The Big-Mouthed Boy," made a living by demonstrating the enormous size of his mouth. He could hold in his mouth up to four large hardboiled hen's eggs or four billiard balls; he could also insert his entire fist or a 100-watt lightbulb into his mouth.

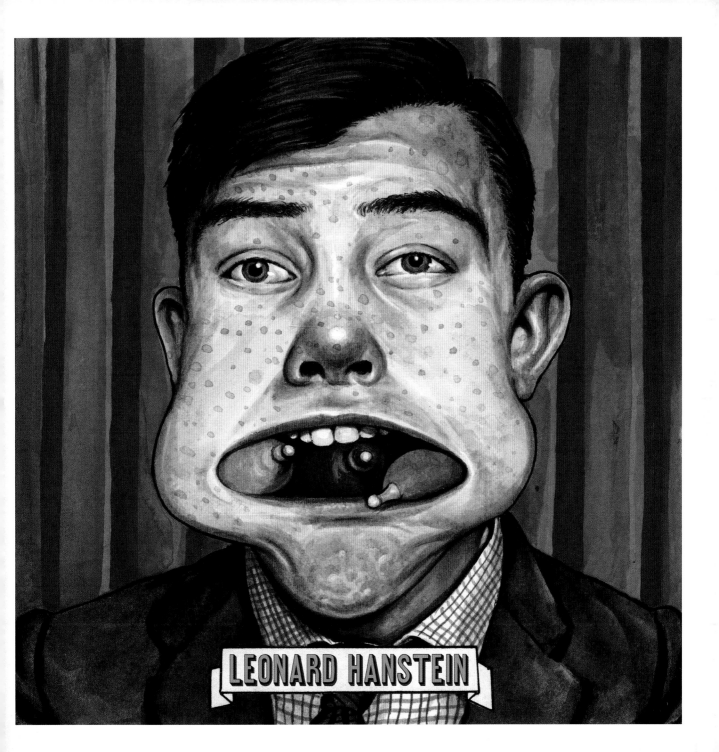

Martin Laurello (1889–1955, Germany), "The Human Owl," had the ability to turn his head around a full 180 degrees and rest his chin on his spine. He was perennially in demand for his unique talents, astonishing and delighting crowds at Coney Island's Dreamland sideshow, Hubert's Museum, and Ripley's Believe It or Not Odditorium, which advertised him as "the only one in the world who can walk straight ahead and look straight behind."

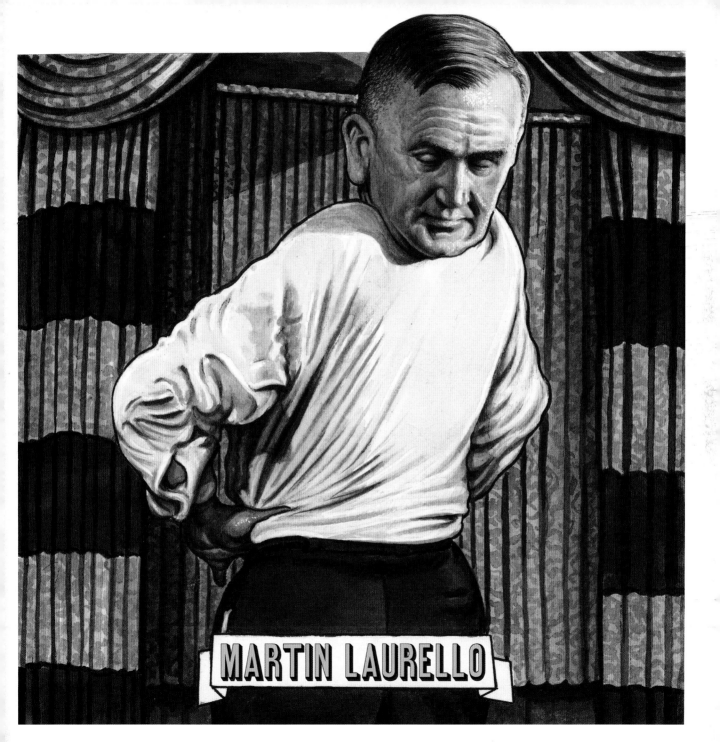

Elizabeth "Betty" Green (life span unknown, Springfield, MA), known as "The Stork Woman" and "Koo Koo the Bird Girl," was the original "Koo Koo," but Minnie Woolsey, also billed as "Koo Koo," is more commonly associated with that moniker. Betty—not technically a "freak," just incredibly homely—toured in the early 1900s with the Ringling Brothers sideshow, performing a comedy act in which she danced in a feathered suit, large bird-feet shoes, and with a feather protruding from her head. She also appeared in the film *Freaks* (1932), billed as "Bird Girl."

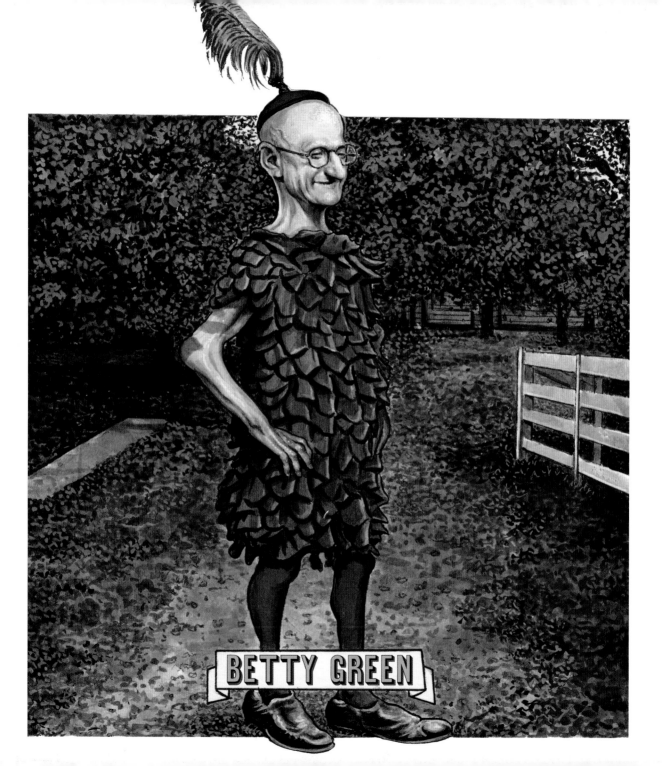

Minnie Woolsey (1880–?, Georgia), known as "The Blind Girl from Mars" and "Koo Koo the Bird Girl," was one of two "Koo Koos." Minnie was very short, had a small head, large ears, a narrow "birdlike" face, and a "beaklike" nose. She would dress in a furry, feathery outfit with tights, oversized bird-feet shoes, a large feather attached to her head, and large round glasses to fully effect her birdlike appearance. She's fondly remembered for her bizarre shimmy dance on the table during the wedding feast scene in the film *Freaks* (1932).

KOO KOO

BIRD GIRL

MINNIE WOOLSEY

Hugo Marcus (life span unknown, Leipzig, Germany) was an armless sideshow performer in Germany who arrived in the United States in the mid-1920s seeking a more lucrative showbiz career. Always formally attired, he performed an act that consisted mainly of doing everyday chores with his bare feet, including lighting and smoking his cigar

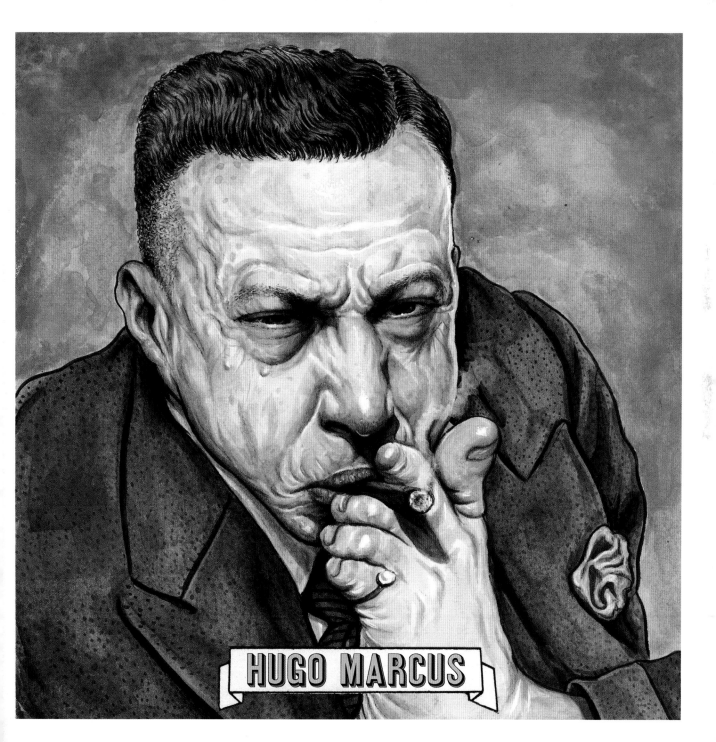

HUGO MARCUS

Frances O'Connor (1914–1982, Renville County, MN), "The Living Venus de Milo," was born without arms yet learned to use her feet as substitutes. She became very adept at performing with her feet normal everyday tasks such as eating, drinking, smoking a cigarette, sewing, and even aiming a rifle and firing it. She appeared in various circus sideshows throughout her career and was a particular favorite with the male audience members for showing off her shapely legs during her act. She also appeared in the film *Freaks* (1932).

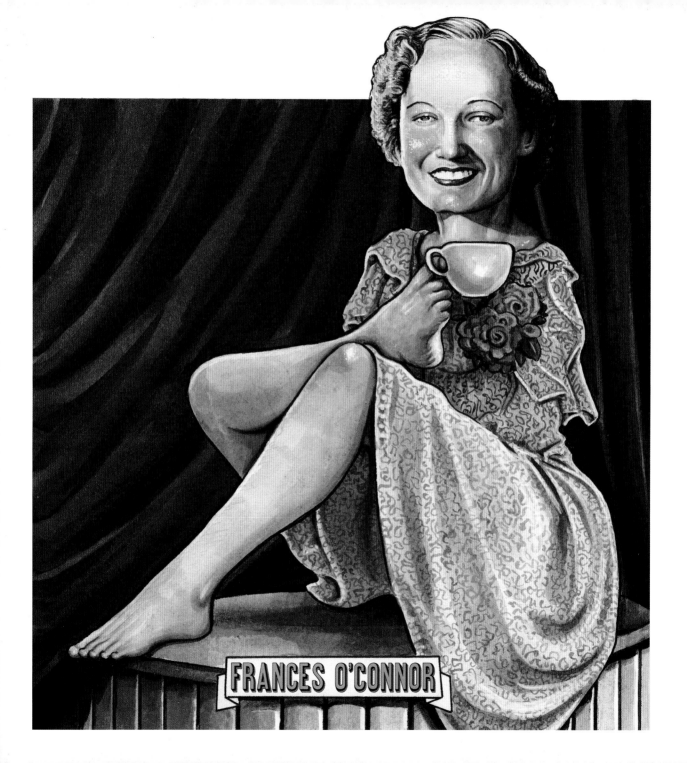

FRANCES O'CONNOR

William Henry Johnson (1842/1843–1926, Liberty Corner, NJ), known as "Zip," "The What Is It?," "The Missing Link," and "The Man-Monkey," was an African-American pinhead who enjoyed an incredibly long career as an exhibited attraction, first in New Jersey, then with P. T. Barnum, who dubbed him "Zip" and concocted an elaborate story detailing his capture in the jungle, playing up the "Missing Link" angle. Barnum had Zip's head shaved leaving just a tuft of hair remaining, dressed him in a furry gorilla suit, and had him appear at first in a cage, rattling the bars and screeching and grunting apelike to the crowd's delight. When released, he would proceed to play the violin (very badly). There has been great speculation about Zip's mental abilities and whether he was a true microcephalic; most assume he was a mildly retarded man being exploited for profit. But on his deathbed, he is said to have whispered to his sister, "Well, we fooled 'em for a long time, didn't we?"

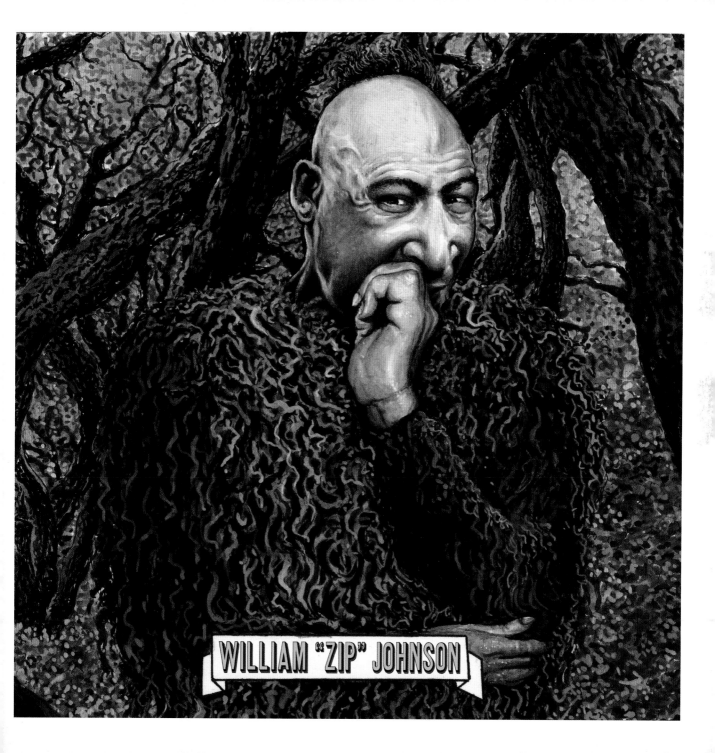

Willie Ingram (1932–?, Decatur, AL), known as "Popeye" or as "The Man with the Elastic Eyeballs," could "pop" his eyeballs almost an inch out of their sockets, delighting sideshow audiences. He often referred to his eyeballs as his "meal tickets." His talents can be seen in the 1974 British film *The Mutations* (also known as *The Freakmaker*)

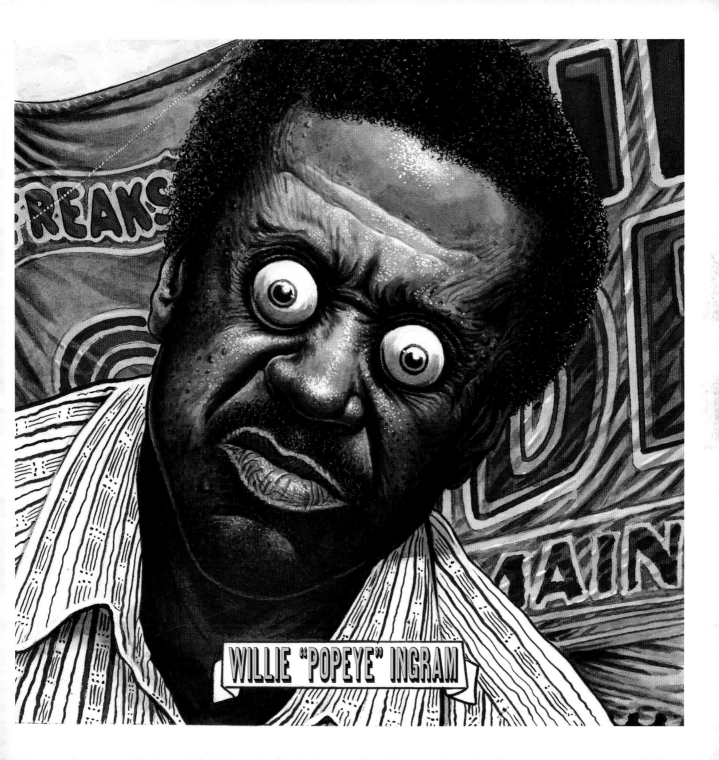

"The Great Waldo" (c. 1920–?, Germany), "The Human Ostrich," was so named because, ostrichlike, he could ingest and gobble almost anything, including whole lemons, rings, watches, frogs, etc. The highlight of his act, for which he was always decked out in a tuxedo, consisted of him swallowing a live mouse and regurgitating it, alive and well. Waldo, a Jew, fled Germany in 1938 and performed in America with the Ringling Brothers Circus and Hubert's Museum in New York.

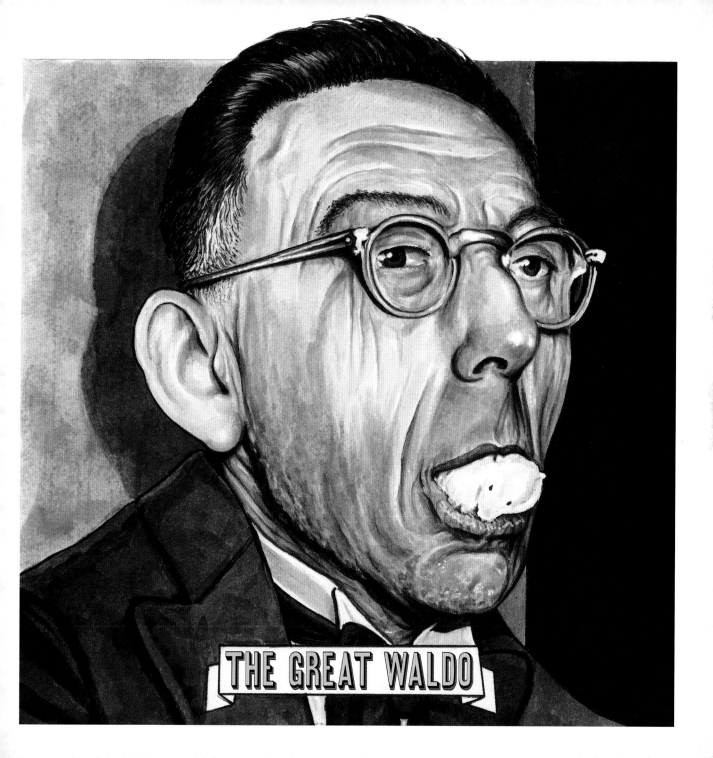

"Prince" Randian (1871–1934, Demerara, British Guiana), known as "The Living Torso," "The Snake Man," "The Caterpillar Man," and so on, was born limbless but was able to move about quite well by wiggling his hips and shoulders in a snakelike motion. He also taught himself to shave, write, paint, and to roll a cigarette with his lips, light, and smoke it, as he memorably displays in the film *Freaks* (1932). Randian was first brought to the United States by P. T. Barnum, who billed him as "The Human Caterpillar who crawls on his belly like a reptile," and he enjoyed a long career as a sideshow attraction always in demand. He married a Hindu, "Princess Sarah," who was completely devoted to him, and they had five (normal) children.

"PRINCE" RANDIAN

Stanislaus "Stanley" Berent (1901–1980, Pittsburgh, PA) was known as "Sealo" or "The Seal Man." With his short, flipperlike arms, caused by phocomelia, that grew directly from his shoulders, "Sealo" enjoyed a career for more than thirty years. He performed such stunts as sawing or splitting wood, sweeping, firing a shotgun, and lathering up and shaving, afterward autographing his publicity photos for appreciative fans. He was very well liked for his pleasing personality.

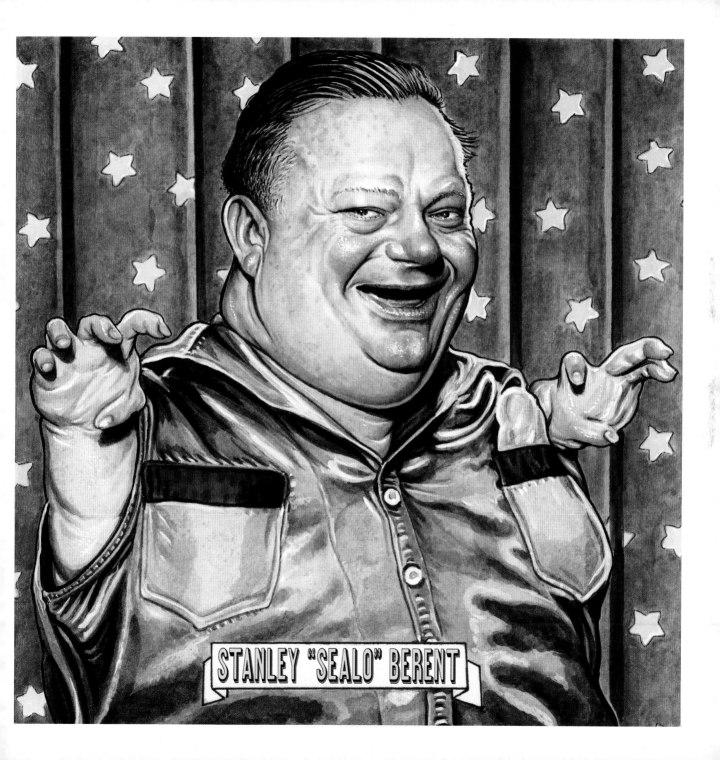

STANLEY "SEALO" BERENT

Ruth Davis (c. 1910s–?, birthplace unknown), "Mignon the Penguin Lady" (*mignon* is French for "dainty" or "cute"), was born with phocomelia, causing her stunted arms and legs and fused fingers, which gave her the appearance of having flippers and a penguinlike gait. She appeared at the Chicago and New York World's Fairs in the 1930s, as well as in many sideshows, where she would play the marimba, often wearing a two-piece bathing suit to highlight her unique physique.

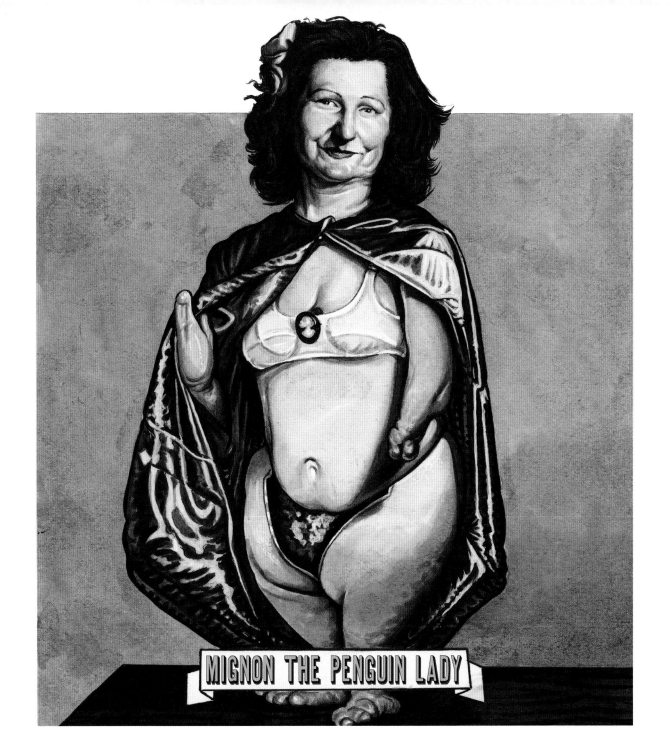

MIGNON THE PENGUIN LADY

Fedor Jeftichew (1868–1904, St. Petersburg, Russia), known as "Jo-Jo the Dog-Faced Boy" and "The Human Skye-Terrier," was afflicted, like his father before him, with hypertrichosis, a condition of excessive hirsuteness. As a boy, Fedor was brought to the United States by P. T. Barnum and given the name "Jo-Jo." Dressed elegantly like a Russian cavalryman, he quickly became a sensation, playing up the dog illusion by barking and growling at the audience.

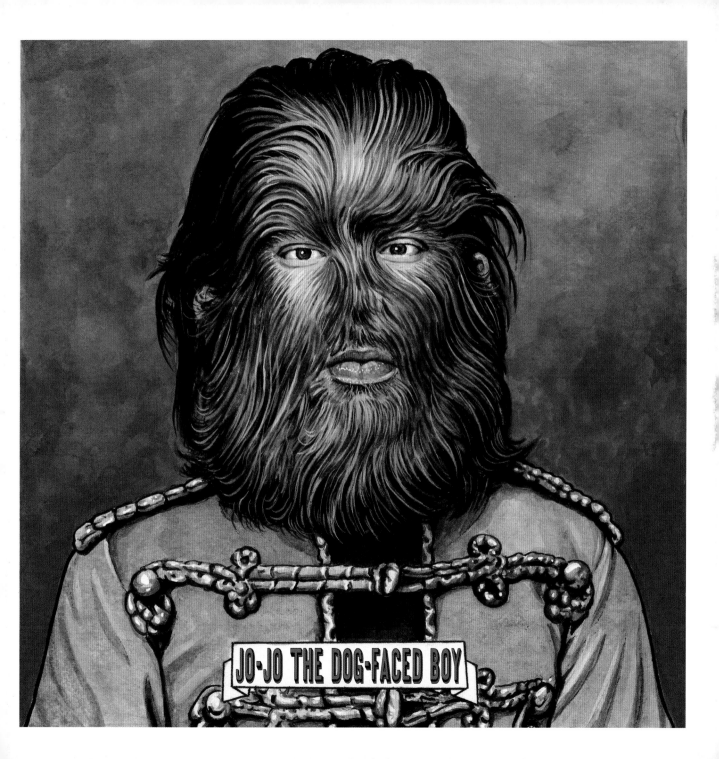

Horace Ridler (1892–1969, Surrey, England), known as "The Great Omi" and "The Zebra Man," was the most popular tattooed sideshow attraction of the early twentieth century. After serving as a decorated major in the British military during World War I (when he received his first small tattoo), Ridler decided to enter show business as a Tattooed Man. First he hired a Chinese tattoo artist to create his initial crude designs, just enough for him to begin making a living exhibiting himself. Later he employed the services of a famous tattoo artist, George Burchett, to finally transform him through striking zebralike patterns covering his body from head to toe into "The Great Omi."

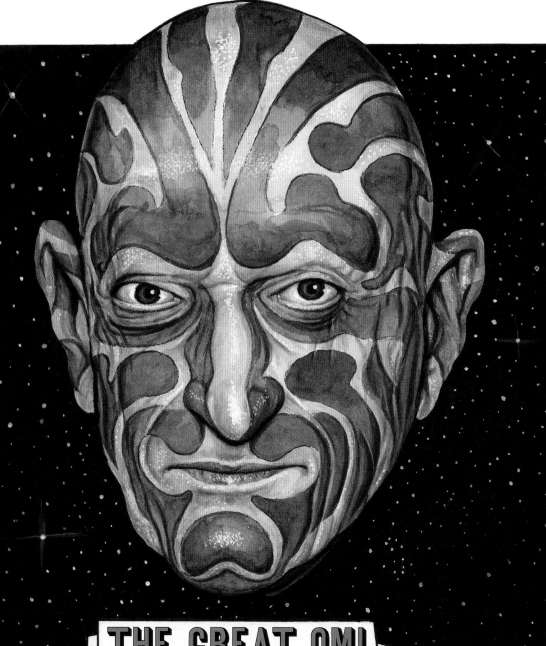

THE GREAT OMI

Ike (Matjus Matina) and Mike (Bela Matina) (life spans unknown, Hungary), "Ike & Mike Rogers," were two of triplet (with Lajos "Leo" Matina) dwarfs, each standing 24 inches tall. Ike and Mike appeared together, performing their popular comedic boxing act and banter at circuses and sideshows in America throughout the 1930s, as well as at the 1933 Chicago Century of Progress International Exposition (World's Fair). All three siblings appeared as Munchkins in *The Wizard of Oz* (1939).

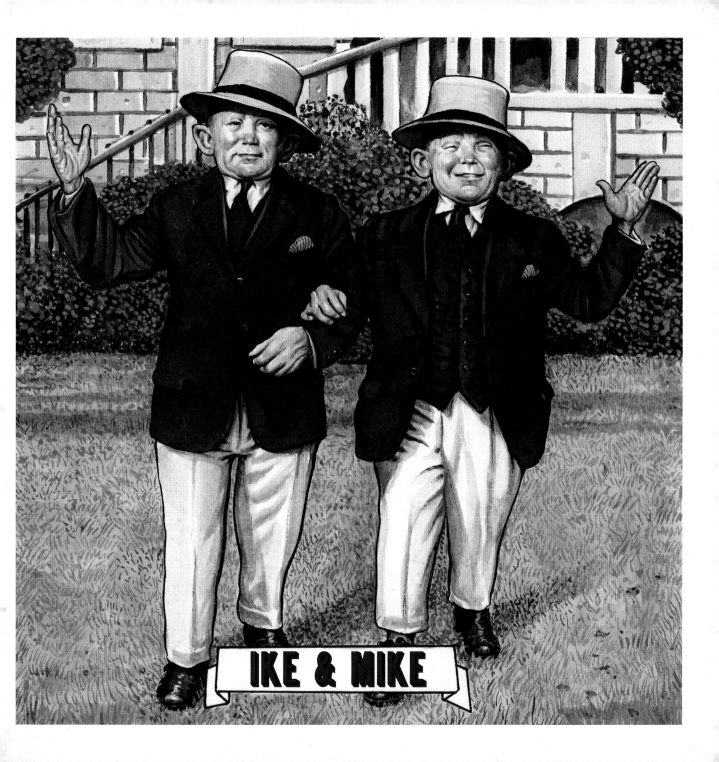

ACKNOWLEDGMENTS

Drew Friedman would like to thank the following people for all their generous help, support, suggestions, and encouragement during the creation of this book: my wonderful wife, K. Bidus, Glenn Bray, Mark Newgarden, Rex Doane, David Burd, Scott Alexander, Irwin Chusid, Tom Leopold, Eddie Gorodetsky, and Bobby London.

Thanks to publisher Laura Lindgren for her beautiful design and brilliant editing, as well as to her copublisher, Ken Swezey, and to Ken Siman at Blast Books and to Donald Kennison for expert copyediting.

Thanks to the great Penn Jillette for his terrific foreword.

Thanks to James Taylor and to Todd Robbins and Bill Griffith.

Special thanks to Mark G. Parker.

The following books and publications were extremely helpful with photo reference and information. All are highly recommended though some are out of print.

The essential series *Shocked and Amazed!*, edited by James Taylor, Kathleen Kotcher, and D.B. Denholtz; *American Sideshow* by Marc Hartzman; *Carny Folk* by Francine Hornberger; *Freaks: We Who Are Not as Others* by Daniel P. Mannix; *Freak Show* by Robert Bogdan; *Freak Show: Sideshow Banner Art* by Carl Hammer and Gideon Bosker; *Human Oddities* by Martin Monestier; *In Search of the Monkey Girl* by Randal Levenson; *The Little People* by Hy Roth and Robert Cromie; *Lobster Boy* by Fred Rosen; *My Very Unusual Friends* by Ward Hall; *Sideshow: Max Rusid's Photo Album of Human Oddities* by Max Rusid; *The Two: The Biography of the Original Siamese Twins* by Irving Wallace and Amy Wallace; *Very Special People* by Frederick Drimmer

www.sideshowworld.com is an overwhelming Web site brimming with rare photos, information, news, and interviews.

ABOUT DREW FRIEDMAN: In the late sixties, at the age of ten, Drew Friedman entered his first Coney Island freak show and encountered, among others, the corpulent and delightful Jolly Jere and has never looked back. Of his two popular books depicting old Jewish comedians, Steven Heller in *The New York Times* wrote, "Friedman might well be the Vermeer of the Borscht Belt." His most recent anthology, *Too Soon?*, was published by Fantagraphics Books in 2010.

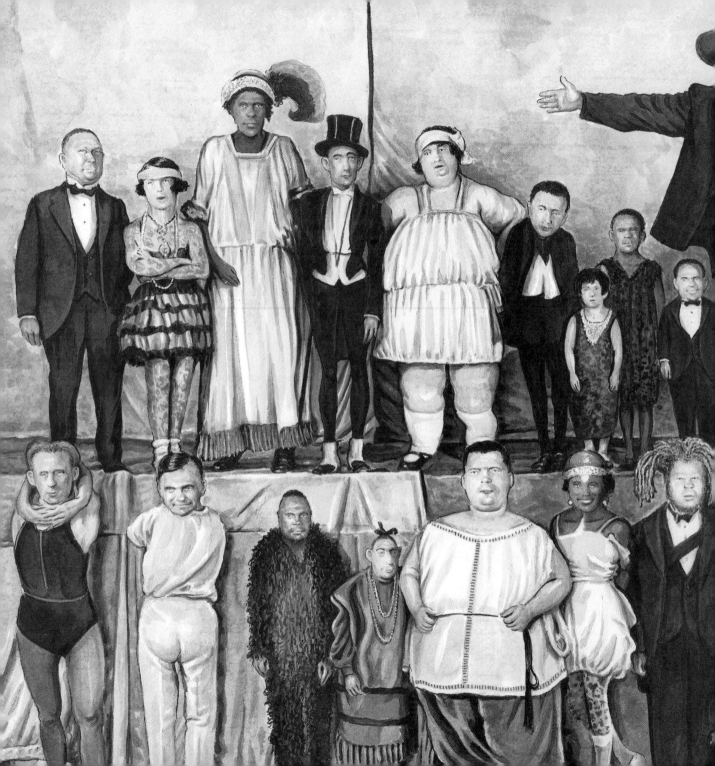